AFRICAN ART
AND OCEANIC ART

AFRICAN ART
AND OCEANIC ART

General Editor
Francesco Abbate

Octopus Books
London · New York · Sydney · Hong Kong

English version first published 1972 by
Octopus Books Limited
59 Grosvenor Street, London W1
Translation © 1972 Octopus Books Limited

Distributed in Australia by
Angus & Robertson (Publishers) Pty Ltd
102 Glover Street, Cremorne, Sydney

ISBN 7064 0064 X

Originally published in Italian by
Fratelli Fabbri Editore
© 1966 Fratelli Fabbri Editore, Milan

Printed in Italy by Fratelli Fabbri Editore

CONTENTS

AFRICAN ART

Negro art has shown its fullest and most mature development in West Africa – an area that may conveniently be considered as bounded to the north by the Sahara, to the east by the Great Lakes region and to the south by the Kalahari desert and mid-Zambesi. In other parts of the continent, craft products certainly abound but it is hard for Westerners to trace a genuine artistic tradition. The underlying reasons for this are not so much cultural as a question of geography and climate. These factors promoted a different pattern of economic growth. In addition, adverse political conditions have included numerous wars and, in East Africa, waves of foreign invasion.

In the realm of art, African sculpture is usually considered in three stylistic groups, each representing vast geographical areas. The first is the

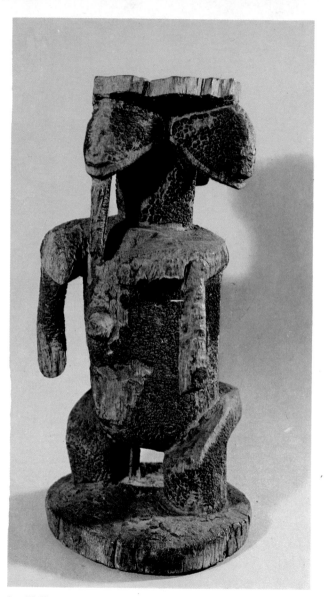

1 *Tellem art : Four-headed figurine, in wood. Paris,*
Musée de l'Homme.

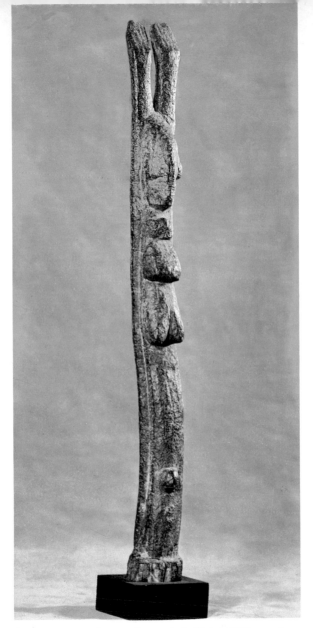

2 *Tellem art : Statue, in wood (h **19** in). Milan, priv.
coll.*

1 Tellem art: *Four-headed figurine*, in wood. Paris, Musée de l'Homme.
Tellem carvings were given a highly characteristic finish. They were made of cooked millet mixed with blood.

2 Tellem art: *Statue*, in wood. Milan, Priv. coll.
These Tellem carvings are enormously elongated. Anatomical detail is sketchy and not related to real-life proportions.

3 Dogon art: *White-monkey mask*, in wood. Paris, Musée de l'Homme.
From Ireli in Bandiagara region, this Dogon mask is named from the figure on top. Its role was one of light relief in ritual dances.

4 Dogon art: *Ancestor figure*, in wood. Paris, Musée de l'Homme.
The Dogon carver stressed some parts of the body at the expense of others; his treatment of form creates figures outside the natural order.

5 Dogon art: *Statue with raised arms*, in wood. Paris, Musée de l'Homme.
The skyward-pointing arms are a recurrent theme in early Dogon work.

6 Dogon art: *House door*, in wood. Paris, Musée de l'Homme.
A swing-door panel, almost certainly with a religious meaning. Three naked figures are depicted in a row, their arms as usual in the raised position.

3 *White-monkey mask, in wood (h 16 in). Paris, Musée de l'Homme.*

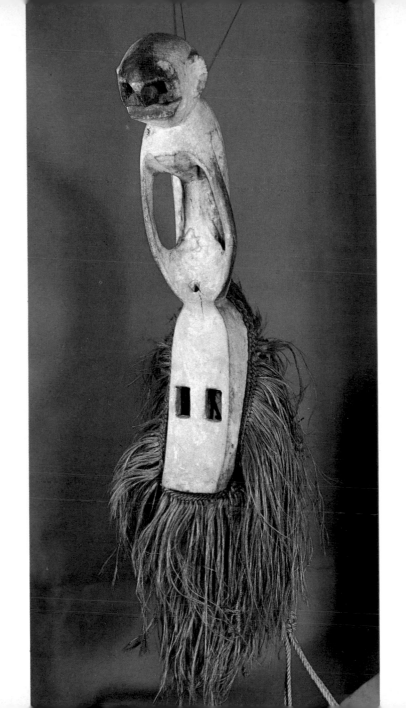

11

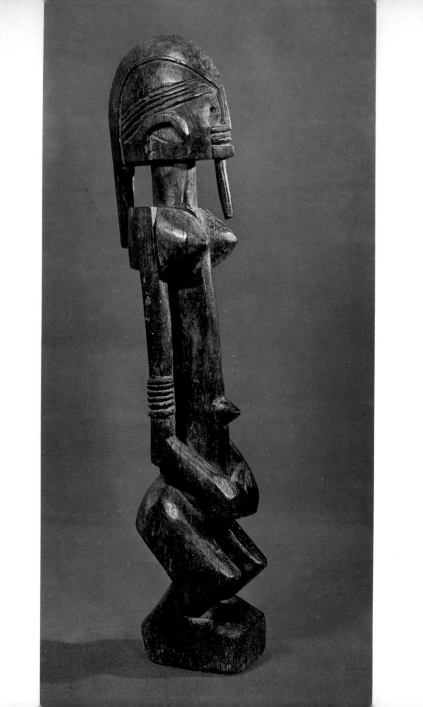

4 *Dogon art : Ancestor figure, in wood. Paris, Musée de l'Homme.*

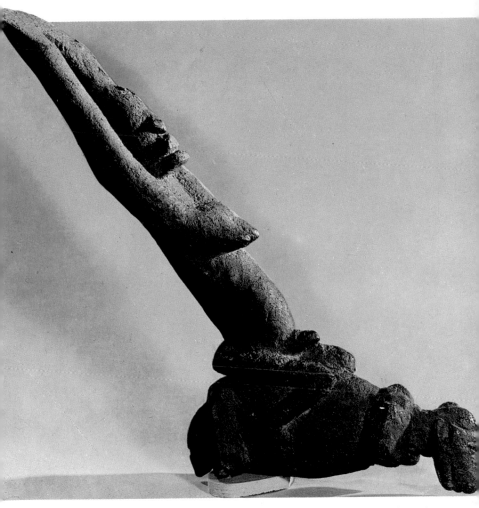

5 *Dogon art : Statue with raised arms, in wood (h **16** in). Paris, Musée de l'Homme.*

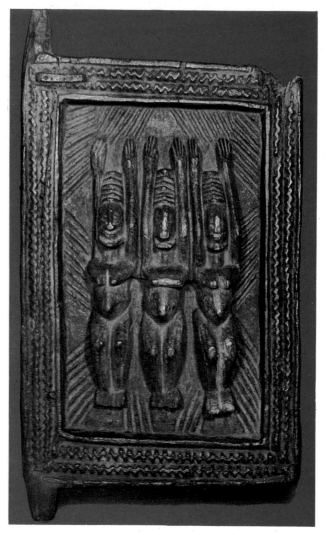

6 *Dogon art : House door, in wood (h **16** in). Paris, Musée de l'Homme.*

Sudanese zone of influence which comprises Mali (formerly French Sudan) together with the Volta region and the northern part of the Ivory Coast. The second is the Guinea Coast which runs from Guinea itself down to Cameroon. The third is the Congo zone of influence which comprises the two Congos plus Gabon, northern Angola and Zambia as far as the Zambesi. Although there are three main stylistic groups, the root concept is one and the same. For art works grow from the beliefs and outlook on life of the West African peoples. Here, there is much common ground. Art forms arise from a basic need, namely to embody aspects of cult worship. Furthermore, there is some identity of technique, due in turn to use of the same materials and kinds of tools. In the field of sculpture, there are two methods of approach – one obtaining results by subtraction, the other by addition. The first embraces sculpture in wood, ivory and stone, in which the work-tool creates form by removing excess material. The second method includes metal-work, in which the artist makes a mould which is then cast by the melted wax process. But wood carvings are likely to deteriorate in time and so, in many places, it became the custom to apply a coating made from various ingredients. At first of practical necessity, this process soon became artistically desirable. In African Negro society, the figure of the sculptor was held in special regard. He often belonged to a particular caste, skill in his calling being passed

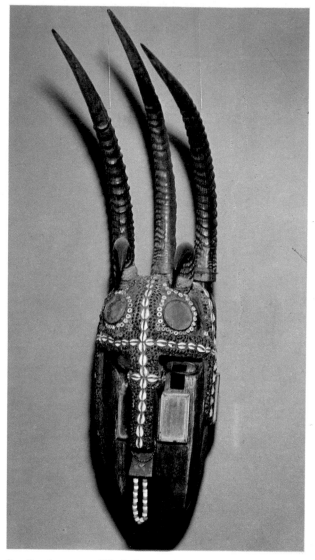

8 *Bambara art : Mask decorated with cowries, in wood*
(h 26 in). Paris, Musée de l'Homme.

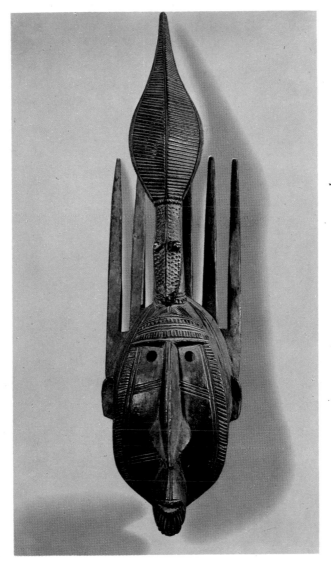

9 *Bambara art : Crocodile mask, in wood. Paris, Musée de l' Homme.*

7 Bambara art: *Zoo-anthropomorphic mask*, in wood. Paris, Musée de l'Homme.
Slits for the eyes, and mouth in the form of rectangles. A domed forehead and strong nose. These features contribute an abstract character to Bambara masks.

8–9 Bambara art: *Mask decorated with cowrie-shells* (on the left) and *Crocodile mask* (on the right), in wood. Paris, Musée de l'Homme.
The Bambara mask-maker gets his human effect by a counter-balance of geometrical units, often without transitional passages. Animal motifs may be included in the picture.

10 Bambara art: *Antelope head-dress*, in wood. Paris, Musée de l'Homme.
The stress here is lengthways. Antelopes of this class often have a head quite separately worked – sometimes it represents an altogether different animal. A secondary figure may be seen astride the horns or on the back of the creature.

11–12 Bobo art: *Masks*, in painted wood. Paris, Musée de l'Homme.
The mask on the left is imaginatively conceived and vividly painted. That on the right, by contrast, derives its impact from under-statement.

13 Mossi art: *Mask*, in painted wood. Paris, Musée de l'Homme.
Above the vizor is a towering head-dress. The decorative content may be reduced to lines and dots, freely disposed on a dusky ground.

14 Kurumba art: *Antelope*, in wood. Milan, Priv. coll.
In the mourning period, head-pieces of this type were tied to the heads of dancers with the purpose of warding off the souls of the dead.

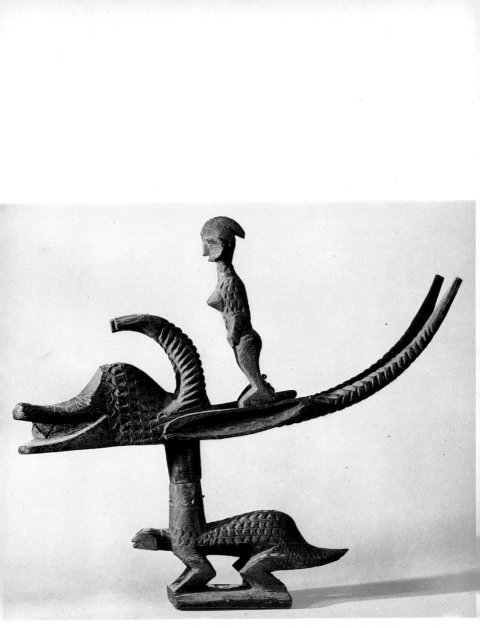

10 *Bambara art : Antelope head-dress, in wood. Paris, Musée de l'Homme.*

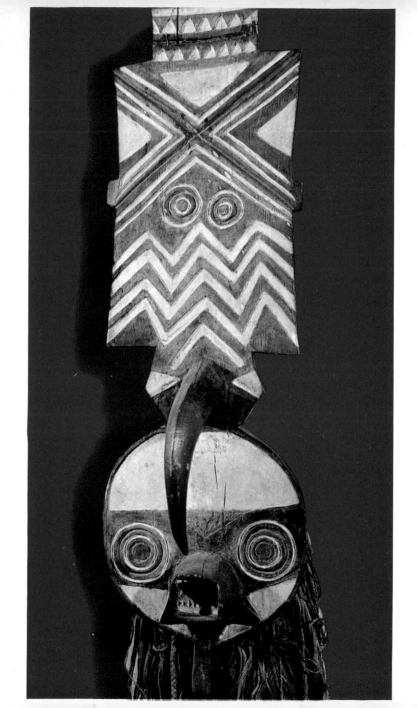

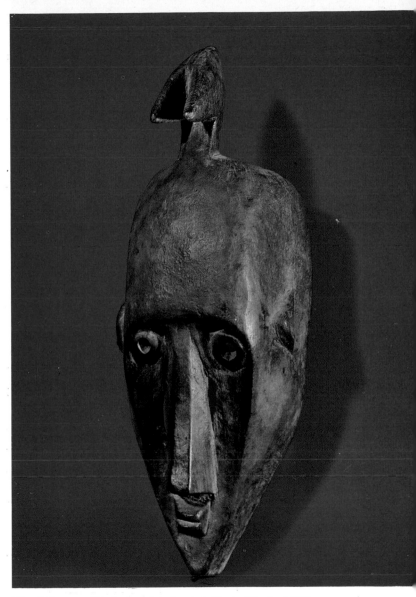

12 *Bobo art : Mask, in painted wood. Paris, Musée de l'Homme.*

11 *Bobo art : Mask, in painted wood (h **48** in). Paris, Musée de l'Homme.*

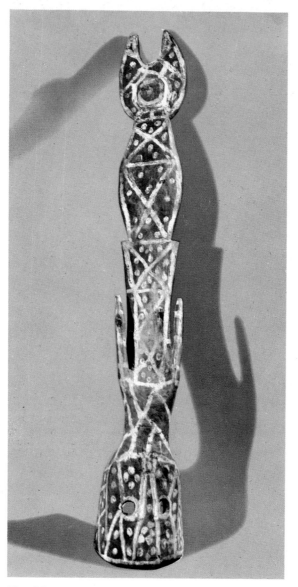

13 *Mossı art : Mask, in painted wood. Paris, Musée de l'Homme.*

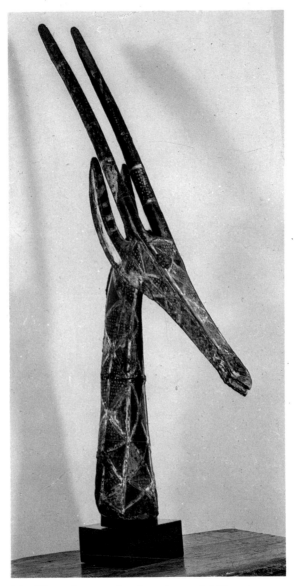

14 *Kurumba art : Antelope, in wood. Milan, priv.
coll.*

achieved a striking degree of cultural advance-
ment. In the period loosely known in Europe as
the Middle Ages, Timbuktu, for example, was
already famous, and it seems likely that local
art was widely influenced by the world of Islam.
The tendency towards abstract expression could
have resulted from contact with these sources.
In the far north of the country is a rocky table-
land – home of the Dogon. Taking the Sudan
region as a whole, Dogon art arouses considerable
interest. For traditional native customs and
beliefs were staunchly maintained despite the
invasion of Islam and then of European civiliza-
tion, a process no doubt facilitated by the region's
remoteness and isolation. Among the oldest art
works preserved by the Dogon are carvings
attributed to a people who lived there before
them. The Tellem, as they were called, are
rather elusive but it is known that they were
driven out by the Dogon at some time during the
fourteenth or fifteenth centuries. Tellem carv-
ings have a distinctive and highly symbolic
style, which places them without a shadow of
doubt in the class of ritual objects. The finish
was made out of cooked millet and blood left
over from sacrificial offerings. When this mixture
was applied to objects, it formed a crust. This
has tended to blur outlines and give them a more
stylized appearance. The process was then
reflected in Dogon work. Indeed, the compact
line and impressive quality of craftmanship may
be discerned in examples of more recent date.

In any event Dogon art is closely linked with everyday custom and behaviour. Dance masks are a typical product, expressing their meaning with boldness and clarity. Some are outsize, like the masks for Sigu rites of birth-guilt expiation. Hard, heavy wood is used for carving, almost indistinguishable sometimes from stone; an earthy grey finish, applied to the carved figures – usually hermaphrodites – heightens the impression. These figures represent the vital spirit of ancestors, male and female. Recognizably human details are sketchy and the overall effect is rigid and inflexible. Carvings of animals proper are less frequently found, though the horse seems to have been a favourite. A specialized form of applied art was strikingly used to decorate the wooden doors and doorways of barns where food was stored. The pattern is usually a row of ancestor figures. The main art-producing centres of the Dogon people are Bandiagara, Sanga and Ireli; their achievements are certainly artistically comparable to the work of better-known civilizations, no matter what period.

Bambara culture

The Bambara people, with a population of about one million, live in westernmost Mali. They speak the Mende language, and comprise the main Sudanese ethnic group. Until quite recently traditional carving flourished and was much admired by art-lovers everywhere.

The dance masks present a curious combination of animal and human features. The masks of the N'tomo secret society – for young men prior to initiation – are especially worthy of note. They show abstracted human features with high domed foreheads, set off by a comb of six or seven horns and decorated with red globules and cowrie shells. A stylistic kinship can be traced between Bambara art and the Marka masks, recognized by a thin beaten-copper overlay on all or part of the surface area. Another interesting Bambara speciality was a dance helmet with an osier or straw base, topped by an antelope figure. It varied to some extent from place to place, but had a well-defined basic pattern. The finest examples are squat-bodied creatures, distinguished by long horns and narrow neck, with an extraordinary crowning crest. There are sub-styles too in these representational carvings though the component parts had much complexity and confusion. An antelope head, for example, may have a dog or chameleon body; sometimes, the antelope carries young on its back. In other examples, the stylization may run to the abstract. At all events, the result is appealing – however hard it may be to identify the original animal model.

Bambara anthropomorphic figures share a basic geometry, and this accounts for their astonishingly abstract quality, even by comparison with work of the afore-mentioned Dogon. The heads are often articulated, the face and neck elongated

15 *Senufo art : Female figurine, in wood. Paris, Musée de l'Homme.*

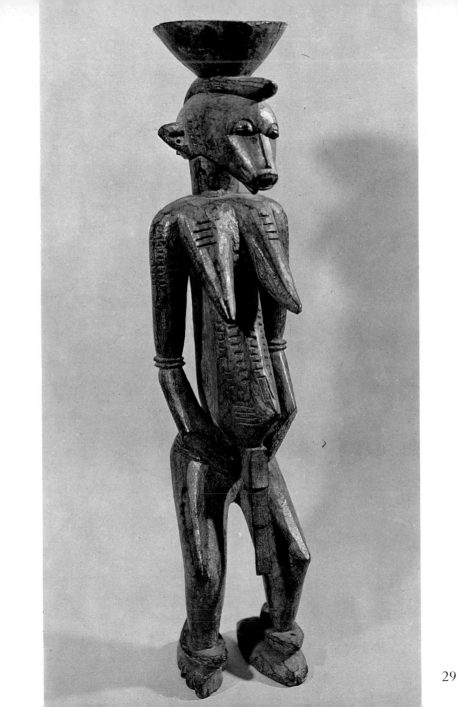

29

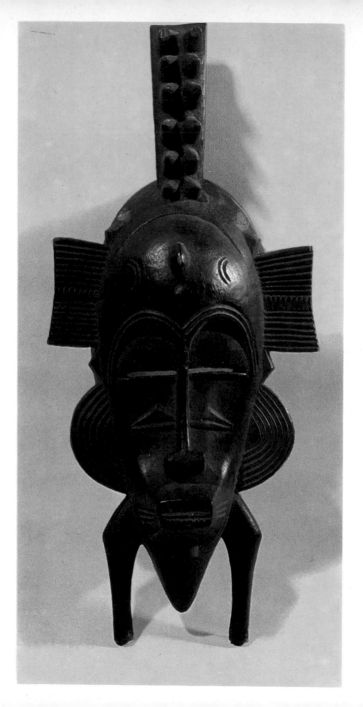

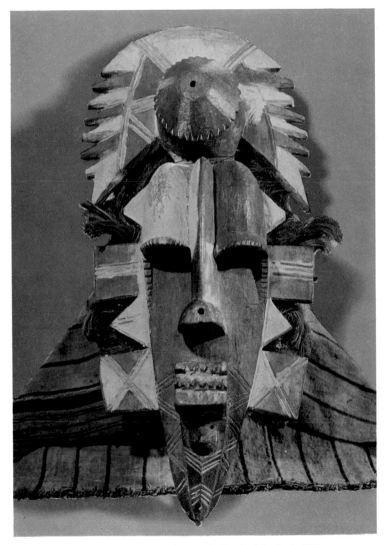

17 *Senufo art : Human mask, in wood. Paris, Musée de l'Homme.*

15 Senufo art: *Female figurine*, in wood. Paris, Musée de l'Homme.
Sharp relief and broken rhythm characterize these wooden figures carved by Senufo artists. Note the projecting chin, breasts, navel and knee-caps.

16–17 Senufo art: *Human masks*, in wood. Paris, Musée de l'Homme.
Human masks and ancestor figures were the main outlets for artistic expression. The masks were variously decorated, for ritual purposes. Indeed, it is difficult to isolate a general pattern among the wealth of sub-styles.

18 Baga art: *Nimba mask*. Paris, Musée de l'Homme.
On this finely-detailed head, geometrical markings delineate the hair and the facial area. This manner is characteristic of Baga work.

19 Mende art: *Human head*, in stone. London, British Museum.
Recovered on Mende land, these stone figurines had been buried. They may be regarded as cult objects, associated with ancestors.

20 Kissi art: *Figurine*, in stone. Paris, Musée de l'Homme.
The Kissi were, in fact, the finders of these stone carvings rather than the makers – so that although they are called Kissi they should by rights be attributed to previous inhabitants of the locality.

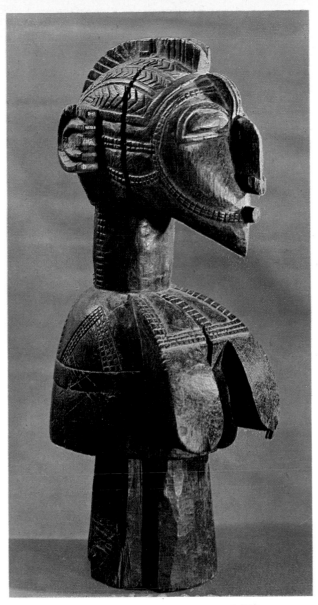

18 *Baga art : Nimba mask. Paris, Musée de l'Homme.*

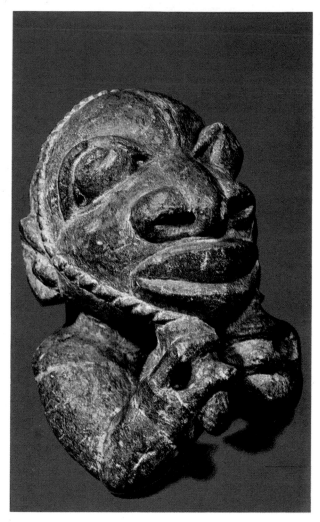

19 *Mende art : Human head, in stone (h 8 in)*. *London,*
British Museum.

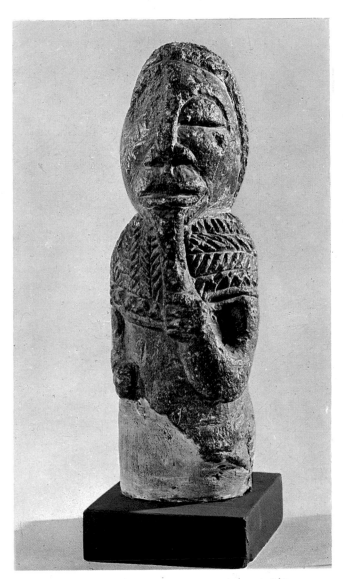

20 *Kissi art : Figurine, in stone. Paris, Musée de l'Homme.*

and the hair indicated by plait-marks. One dance head-dress arranges these heads in tiers of decreasing size.

In the field of iron-work, the making of staves or sceptres is noteworthy. They terminate in a point and are capped by human figures. Expertly fashioned, these display an overall strength and still manage to include a wealth of telling detail. The end result retains its impact while achieving perfect balance.

Mossi and Bobo masks

The Mossi live in south-eastern Mali, and their art is notable for its masks, rather than for carved figures which are few and far between.

The masks for the Wango secret society are of special interest. These are huge and although made of a single piece of wood taken from a larger block, they divide into two component parts – a face-piece and a human figure placed on top. They are painted and patterned in colour, white and reddish-brown predominating. The human figure is modelled with skill and vigour, and is indicative of a very high order of imagination on the part of the local mask-makers.

In the Aribinda region, the Kurumba have a speciality of their own. Originally intended as a dance helmet, it represents an antelope head with long horns and a strong, slanting neck, painted in black, red ochre and light blue, with red globules to complete the decorative scheme. Some of these pieces are outstanding, with a

harmonious balance of naturalism and stylization. The Bobo also are famed for their masks. They live on the Volta and Mali borderlands, so it is hardly surprising that their work often shows the influences of Dogon and Mossi art. Favourite themes are the ever-popular human face, as well as birds and beasts of burden. Their treatment of form is stylized to a degree. Some prime specimens have very little relief and are exaggerated lengthwise and sideways, but achieve a three-dimensional effect through the medium of polychrome painting, which is applied, to striking effect, in red, white, brown and black.

The Senufo
From the geographical point of view, the Senufo are really part of the art sector of the Guinea Coast. But in fact, Bambara and Dogon influence may be distinguished, especially among the tribal groups inhabiting the far north of the region. Isolating physical factors have forestalled stylistic exchanges with areas to the south, and Senufo art is thus localized and varied. The main focus of interest concerns carved ancestor-figures, male and female. The representation of the human body is highly stylized. A complicated head-dress tops an elongated head, the face is heart-shaped and the shoulders broad and curving; breasts and belly are emphatically pointed and the lower limbs slightly flexed, with points at the knee. The result is a powerful image.

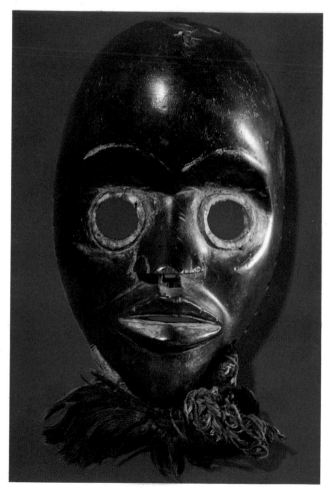

21 *Dan art : Mask, in wood. Paris, Musée de l'Homme.*

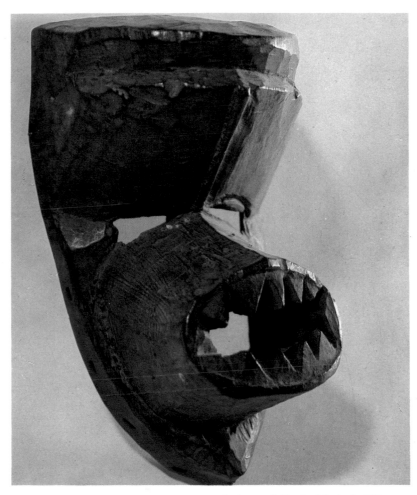

22 *Dan art : Mask, in wood. Paris, Musée de l'Homme.*

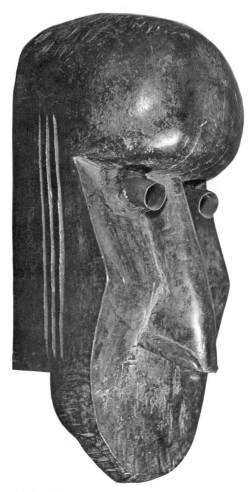

23 *N'Gueré art : Mask in wood. Paris, Musée de l'Homme.*

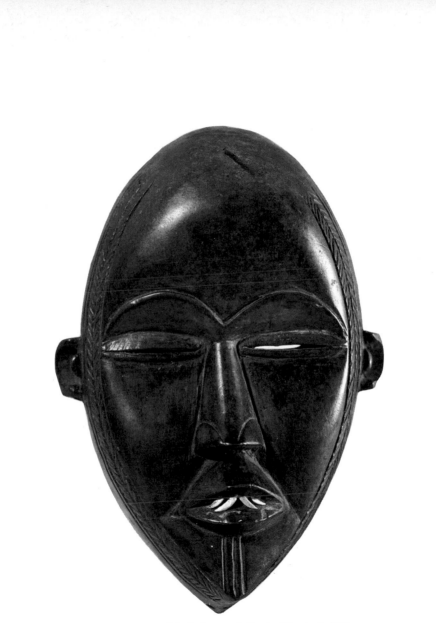

24 *N'Gueré art : Mask, in wood. Paris, Musée de l'Homme.*

21–2 Dan art: *Masks*, in wood. Paris, Musée de l'Homme.

Dan art concerns itself principally with the making of wooden masks. Some are naturalistic, others are deliberately distorted, stressing certain features or including animal characteristics.

23 N'Gueré art: *Mask*, in wood. Paris, Musée de l'Homme.

A typical N'Gueré mask, as shown by the domed forehead, the singular treatment of eye openings, the long ridged nose and the peaked cheek-bones.

24 N'Gueré art: *Mask*, in wood. Paris, Musée de l'Homme.

Here, typical N'Gueré and Dan features are combined. The result is a successful blend of natural and geometrical aspects.

25 Guro art: *Human figure*, in wood. Milan, Priv. coll.

The trim body and short, chubby legs are capped by a head with arching brows, almond-eyes, straight nose and tiny mouth.

25 *Guro art : Human figure, in wood (h 20 in). Milan, priv. coll.*

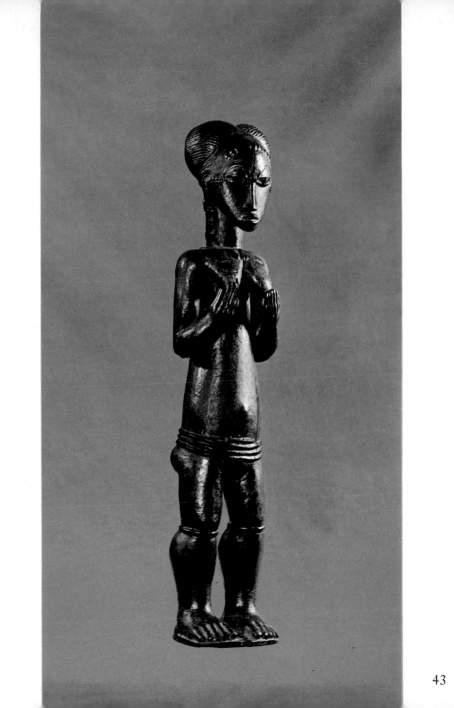

The *deble* constitute another particular art-form. These ritual figures are usually female, with long legs terminating in a solid shoe-piece. The *deble* is used for beating the ground to the rhythm of a special dance. By this means, communication is established with the ancestors and the land's fertility ensured. Again, the motif of the man on horseback occurs but less frequently than other themes. The rider sits his mount, slender and erect, in linear contrast to his long-bodied horse. Senufo artists have made a number of ritual masks, foremost among them being the spitfire group. These combine human and animal features, hyenas being frequently modelled. Widely found if less dramatic is another group of masks presenting a human face above a stylized tortoise figure. On objects in daily use, the hornbill is one of the recurrent motifs. The bird is common in the northern regions and serves as a Senufo emblem. The tortoise has already been mentioned, but the crocodile, lizard and snake may also be seen on everyday objects. Tam-tam or wooden doors furnish examples of applied art in this field. The hornbill is carved as a separate piece, in addition, sometimes of massive proportions but always from a single block of wood. Here, the Senufo artist can display his prowess to the full.

Cultures of Guinea
There is a clear differentiation of style between Sudanese work and the art products of the

Guinea Coast. Stricly speaking, the work of the Baga people comes in the latter category. Their crowning achievement lies in the making of huge *nimba* masks. Cut from hard wood and thus fairly heavy, a mask of this kind presents human lineaments and a female bust. Curving shoulders and hanging breasts are supported on four legs. The head is long rather than wide, the nose prominent and arched over a button mouth. During ceremonies connected with the Nimba cult fertility rites, such masks are carried along shoulder-high. A long hair-covering made out of raffia conceals the figure of the dancer who holds the mask up by the leg supports. There is in addition a ritual object with a *nimba*-type head. These *matioli* elongate the head atop a short cylindrical neck, which in turn rests on a circular base constituting a receptacle. Individual figures are included within the Guinea art range, mostly made from soapstone and known by the tribal name appropriate to the site where unearthed. They are certainly quite old, some authorities maintaining that they are of great antiquity. They have been found buried at various depths. The personages represented have features of negroid type, strongly emphasized. It seems probable that they served as fertility spirits – at least, that is how the Kissi look upon them. But there have been finds elsewhere, well outside Guinea. Some have come to light, for example, among the Mende of Sierra Leone. Unfortunately, the date and the

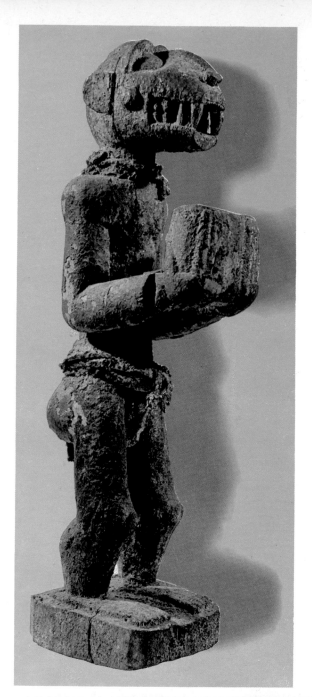

26 Baulè art :
Gbekze the monkey-
god, in wood (h 29 in)
New York, Museum
of Primitive Art.

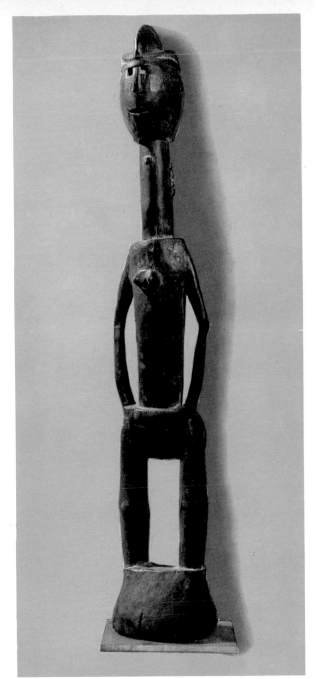

27 Baulè art :
Female figure, in
wood (h 22 in). New
York, Museum of
Primitive Art.

26 Baulè art: *Gbekze the monkey-god*, in wood. New York, Museum of Primitive Art.
An animal head on a human body. This monkey-figure is the god Gbekze, judge of all souls.

27 Baulè art: *Female figure*, in wood. New York, Museum of Primitive Art.
It is interesting how this piece avoids over-statement. Baulè work in general has a harmony of its own, whether interpreted in line with natural rhythm or reduced to geometrical terms.

28 Baulè art: *Receptacle for divination*, in wood. Paris, Musée de l'Homme.
To derive omens and foretell the future, mice were put in this container where they displaced little sticks arranged in a special order.

29 Baulè art: *Gu mask*, in wood and brass. Milan, Priv. coll.
Long narrow eye-slits, smoothly arched brows, prominent nose: treatment of the facial planes is punctuated by tribal-marks.

30 Baulè art: *Pendant in the form of a mask*, in gold. Paris, Musée de l'Homme.
This was worn round the neck during Gold Festivals, which were held every two years as the young men came to manhood. The face is oval, the beard indicated by an ear-to-ear circlet of projecting curls.

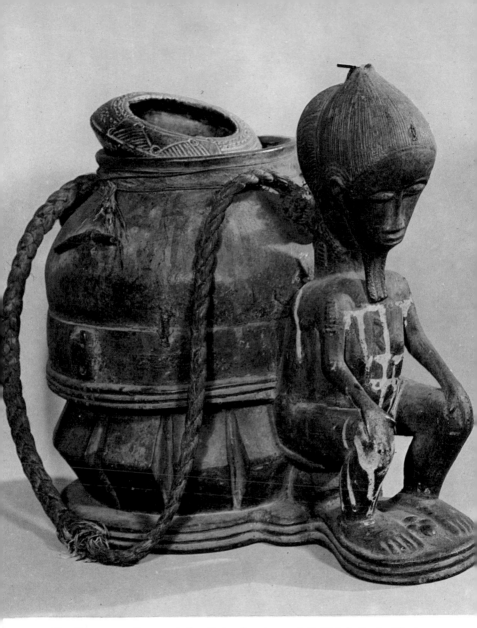

28 *Baule art : Receptacle for divination, in wood (h 24 in). Paris, Musée de l'Homme.*

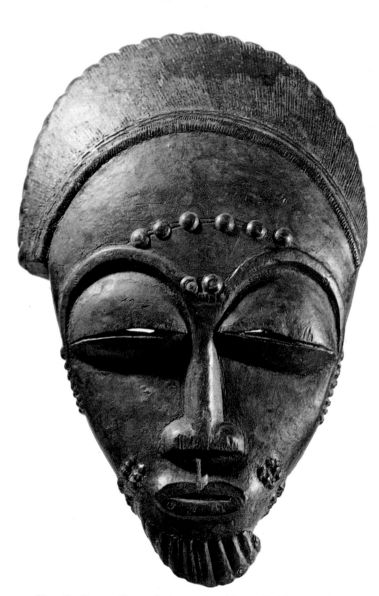

29 Baulè art : Gu mask, in wood and brass (h 12 in). Milan, priv. coll.

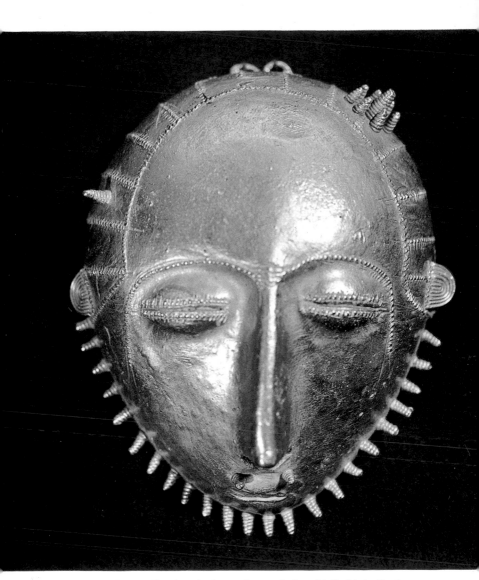

30 *Baulè art : Pendant in form of a mask, in gold (h 4 in). Paris,*
Musée de l'Homme.

people responsible are not known. In respect of the Mende, mention may be made of the dance helmets worn by members of the Sande or Bundu women's secret societies at initiation rites. In the lower part of the mask, the human face is outlined and surmounted by an elaborate head-piece.

Cultures of the Ivory Coast

In the western part of the Ivory Coast, the main tribal groups are those of Dan and N'Gueré. Here, on the borders with Liberia and Guinea, in particular along the upper stretches of the Cavally, are to be found some of the Guinea region's most fascinating art products. The carving of wooden dance masks is the sole artistic occupation, and it is hard to account for the total lack of any tradition of figure-carving. The mask therefore takes pride of place as a focus of interest in the ancestor cult. The fact that they are used on social and political as well as religious occasions would to a large extent explain the variety of mask-types encountered, arranged in sub-groups according to stylistic affinity. The carvers deliberately chose their career, whereas in other places it was a question of caste and inheritance. This led to new and original departures and a less rigid observance of the traditional treatments.

Sometimes, the human face is quite naturally rendered, sometimes it is abstract in the extreme. The former are in the style of Dan, the others

31 *Agni art : Female grave-figure, in terracotta. Paris, Musée de l'Homme.*

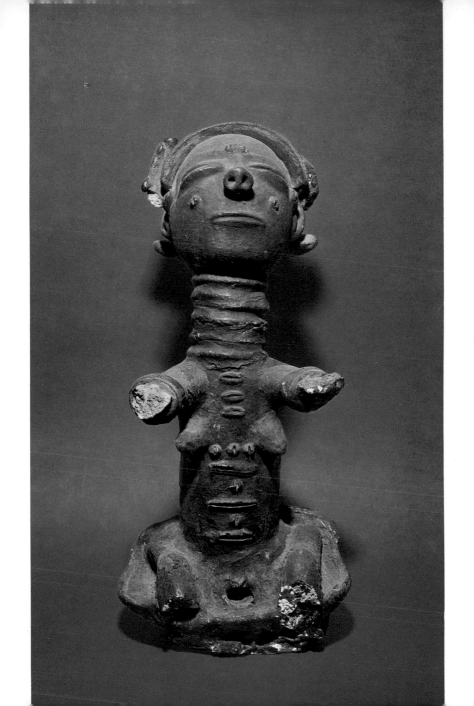

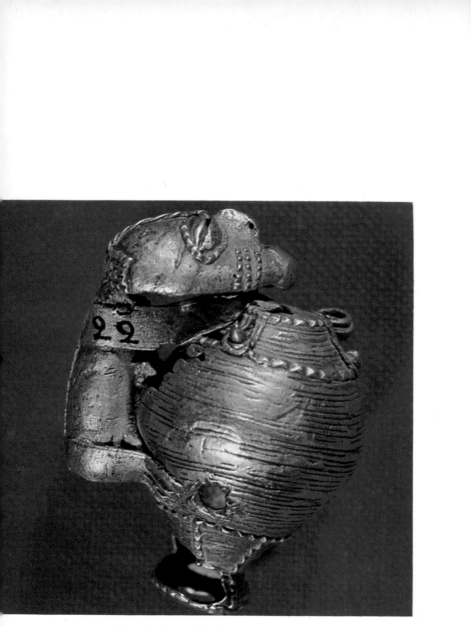

32 *Agni art : Pendant, in gold. Paris, Musée de l'Homme.*

33 *Ashanti art : Jewel, in gold. Paris, Musée de l'Homme.*

31 Agni art: *Female grave-figure*, in terracotta. Paris, Musée de l'Homme.
The artist has been so very precise in respect of body-marks, neck-bands and head-dress that a reference is obviously intended to the dead woman's clan or tribe.

32 Agni art: *Pendant*, in gold. Paris, Musée de l'Homme.
By contrast with the linear geometry of Baulè jewels, the Agni goldsmith seems to have been allowed more imaginative play. As a result, his work is noted for formal complexity.

33 Ashanti art: *Jewel*, in gold. Paris, Musée de l'Homme.
Ashanti goldsmiths enjoyed a privileged position in recognition of their skill. Gold symbolized the sun, the centre of the universe.

34 Ashanti art: *Doll*, in wood. Paris, Musée de l'Homme.
In the restricted range of Ashanti carvings, these dolls represented fertility symbols. Women wore them on their backs, to ensure fine healthy sons.

35 Fon art: *Gu the war-god*, in wrought iron. Paris, Musée de l'Homme.
This statuette seems surprisingly modern, both as a whole and in its parts. A fantastic figure perhaps, but the angular treatment of the planes is very attractive.

36 Fon art: *Seated woman figurine*, in bronze. London, British Museum.
Without a doubt this is comparatively recent work. There are tell-tale signs in the natural pose with the arms circling above the lap, the placid face, the skirt-bands, and the garment billowing on the seat.

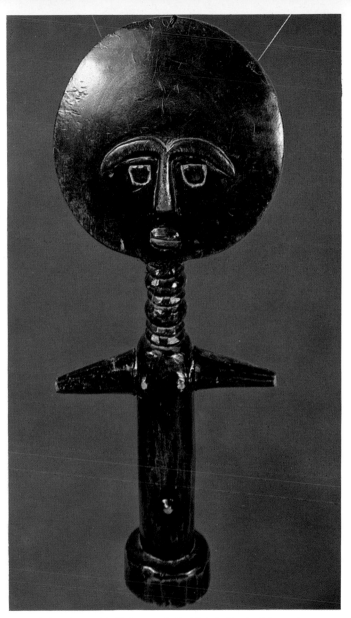

34 *Ashanti art : Doll, in wood (h 15 in). Paris, Musée de
l'Homme.*

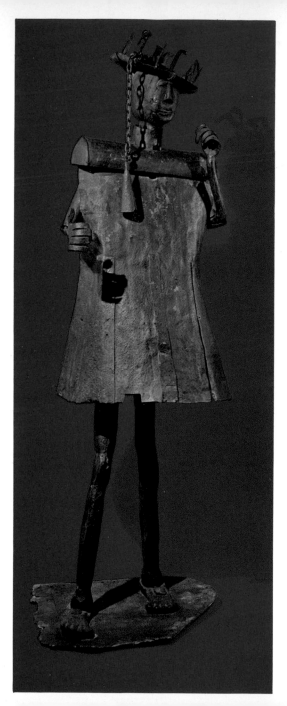

35 *Fon art : Gu the war-god, in wrought iron (h **66** in). Paris, Musée de l'Homme.*

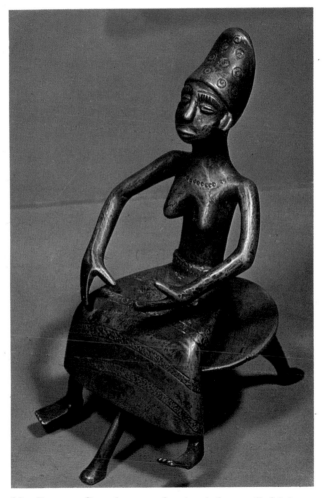

36 *Fon art : Seated woman figurine, in bronze (h **6** in). London, British Museum.*

more favoured among the N'Guéré. The latter have created cubist-type efforts, especially in animal masks, such as that of the wild boar. Contacts have produced some hybrid forms, both realistic and abstract in style. A mixture of human and animal features is not uncommon – a bird beak, for example, might replace a human mouth and nose. Dan masks have a shiny, even finish which adds to their attractiveness. The N'Guéré masks are more notable for polychrome decoration in white, red and black.

The Guro tribal group inhabit the central region of the Ivory Coast to the east of the upper Cavally. Like the Dan and N'Guéré, the Guro apparently confine their output to the making of masks. Some have human features and some animal, others share a mixture of both. Many are refined to near-decadence. A special feature here is the use of body-marks, another the broken-line rendering of hair.

The small shuttles used at the loom, mostly with a carved head or animal figure, are highly finished, much prized for their artistry and quite special to the Ivory Coast.

The Baulè

Looking at Guinea Coast art as a whole, until quite recently the major ethnic group of the Baulè were prominently represented. They live in the heart of the Ivory Coast, with the Guro to the west and the Senufo to the north. Their carvings form a point of contact between the

Sudan area and the Coast. Cylindriform structure is softened by the surface treatment; hair and tribal body-marks are rendered by means of inlay. Results are highly refined and ancestral subjects most frequently treated. But some Baulè figurines step outside traditional observance and seem to be stylized portraits with no specific ritual objective in view. In such cases, we find art for its own sake and this is fairly exceptional within the range of African culture. Less often found are near-human figures of the monkey-god. Detail is not so precise and an outer crust is formed by dipping them in sacrificial liquids, yet they are possessed of undeniable vigour.

Dance masks are another Baulè art speciality. They may be divided into three main types. First come masks with human features, which are fairly uncommon, near-realist and always stern. The much larger, highly abstract masks are polychrome painted rather than gloss finished; in them, the human face beomes a great flat disk, while smaller spheres convey the heavy-lidded eyes with a rectangular slit for the mouth and, in most cases, a pair of horns meeting overhcad. These masks are typical of the Nanafué area, and were used in rites for warding off misfortunes. A third group of masks displays animal features, one frequently-found example being a helmet representing a cow's head. Baulè art extends further, to cover objects of ritual significance and everyday use. These include vessels for divination, others for

holding cosmetics and shuttles for the loom. The entrance to houses had a swing-door made of a single panel; these were often decorated with low-relief carving on human and animal themes.

The Agni

The warrior tribes of the Agni, inhabiting the eastern seaboard of the Ivory Coast, are associated with a special art-form, namely terracottas. These are thought to commemorate dead persons of high rank and were cult objects insofar as deemed to house the soul of the departed. For this reason, they were tended in a type of shrine. The head, which is the focus of attention, is given near-realistic treatment especially the head-dress. A long annular neck joins head to body, which is freely rendered, usually cylindriform, with arms like sticks, and thus in striking contrast to the head. But the face has all the sadness of expression consonant with the mystery of death. Judged as portraits they are memorably impressive.

The Agni also produced wood-carvings that survive. Their approach is akin to that of the Baulè, if a little less realistic. The figures of ancestors that illustrate this point are fairly rare.

The Ashanti

In the region of present-day Ghana, there flourished in the seventeenth century the kingdom of Ashanti. The land's gold deposits were

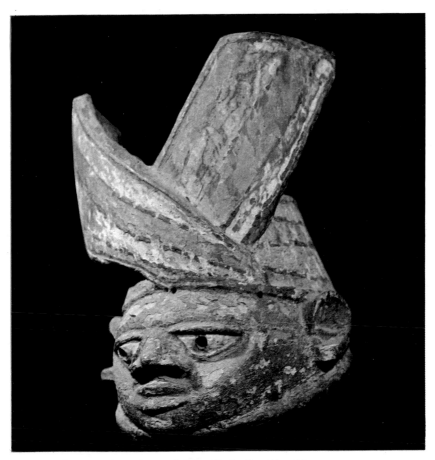

37 *Yoruba art : Mask, in wood. New York, Brooklyn Museum.*

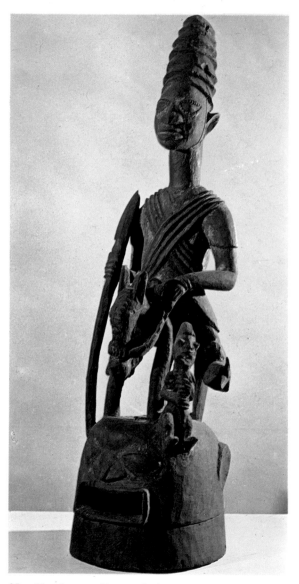

38 *Yoruba art : Epa mask, in wood. New York,*
Museum of Primitive Art.

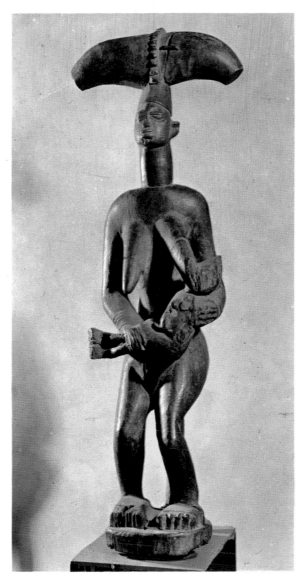

39 *Yoruba art : Female figure, in wood (h 28 in).*
New York, Museum of Primitive Art.

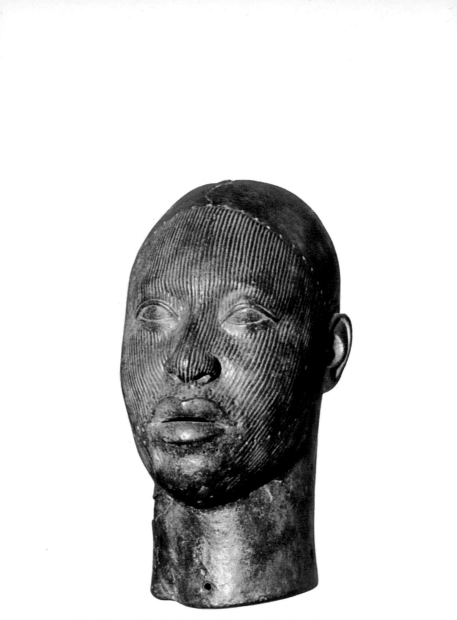

40 *Ife art : Head of ruler, in bronze. London, British Museum.*

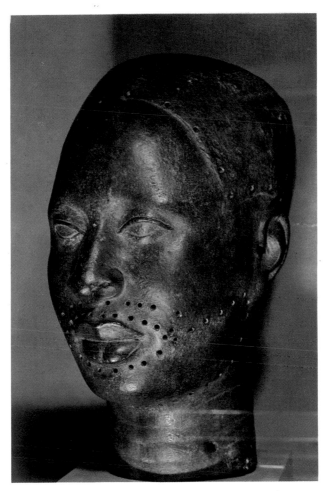

41　*Ife art : Head of ruler, in bronze. London, British Museum.*

37 Yoruba art: *Mask*, in wood. New York, Brooklyn Museum.
Each secret society has its own kind of masks. They vary in size and in weight, and were worn by participants in frenzied ritual dances.

38 Yoruba art: *Epa mask*, in wood. New York, Museum of Primitive Art.
Epa masks are a special type, with a vizor and variously disposed figures above, often on horse-back.

39 Yoruba art: *Female figure*, in wood. New York, Museum of Primitive Art.
This motherhood symbol is connected with the cult of Shango, god of thunder and lord of birth. His emblem, the double-headed axe, adorns the head-piece.

40–1 Ife art: *Heads of rulers*, in bronze. London, British Museum.
Among the masterpieces of African art, these heads – part real and part ideal – strike a balance between a natural portrait and a higher order of composition.

42–3 Benin art: *Figure*, in bronze. *Sceptre with a man on horse-back*, in ivory. London, British Museum.
Benin art includes bronzes as well as many objects made from ivory – masks, spoons, cups, necklaces, sceptres and elephant's tusks worked in relief.

42 *Benin art : Figure in bronze. London, British Museum.*

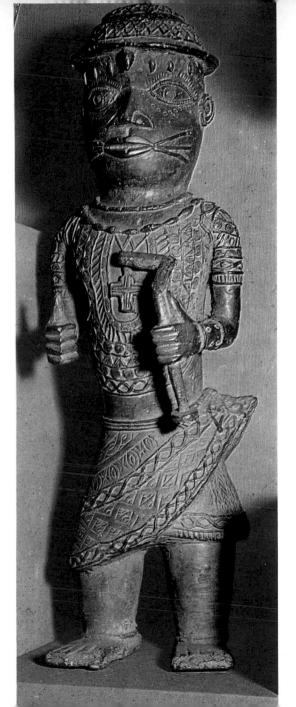

69

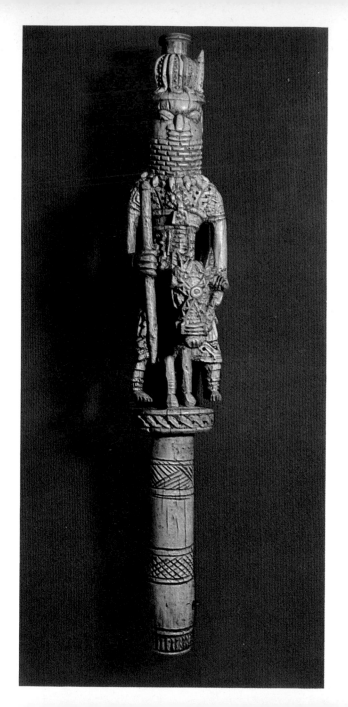

worked by this people and they enjoyed great wealth. A salient feature of their art lay in creating little dolls, which young women used to carry on their backs. They were made of wood and the head was like a thin disk, with a single line for the nose and brows and a tiny mouth. The neck was long and slender, apparently annular and the body was no more than indicated by a cylindrical shape.

Gold-dust was the currency in Ashanti and little bronzes were used as weights. They were made by the melted wax method and cover the most diverse range of subjects, including various kinds of fish, insects and animals. Human figures also occur, along with plant species and some miscellaneous objects. But the meticulous detail, general refinement, originality and charm of these small pieces combine to make them cherished for their art. The Ashanti produced, in addition, fine bronze receptacles. These were decorated and some carry a head or group of tiny figures on the cover.

Recently a number of enormous masks have come to light in Ghana, some as much as seven feet high. The lower part is like a shield and tapers towards the base, the upper part having large horns or a geometric pattern. Polychrome painting over the whole surface area of these masks give them an almost surrealist effect.

43 *Benin art : Sceptre with man on horse-back, in ivory. London,*
British Museum.

The Fon

Continuing this brief review of the Guinea Coast, before coming to Nigeria, the Fon people of Dahomey possess a wonderful heritage of extremely rare outsize sculptures, made of wrought-iron work, that rank among the most dazzling works of art to have emerged from Black Africa. An outstanding example is the Gu image, a strikingly modern-looking war god, at the Musée de l'Homme in Paris. This creation is also one of the largest known African statues in iron.

The Yoruba

This leading tribal group of Nigeria lives in the the south-eastern quarter. Yoruba art is unique in presenting some uniformity of style. The artforms in which they have enjoyed greatest success are dance masks and anthropomorphic carved figures. In the dance mask category, a common type represents a human head, some more stylized than others; these are crowned by mixed groups of people and animals, the whole painted in various colours and carefully carved in the round from a single large block of soft wood. The emphasis in the figurines is again on the godhead, the faithful and the ancestors, in connection with the Shango cult. This thunder god had a double-headed axe for an emblem. The small figures known as 'twins' were cult offerings, in the event of the death of either or both of them. The carved figure was a

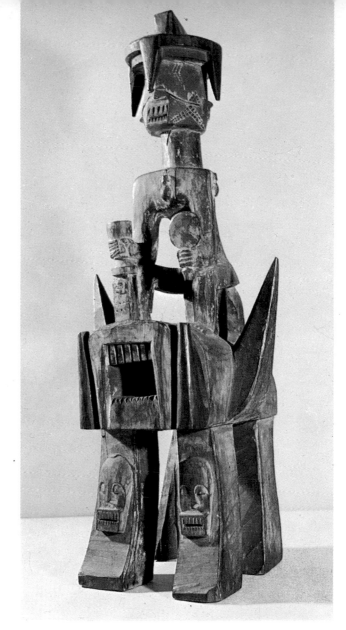

44 *Ijo art : Guardian spirit, in painted wood. New York, Museum of Primitive Art.*

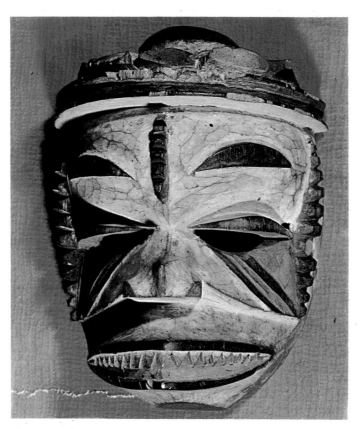

45 *Ibibio art : Mask, in carved and painted wood. London, British Museum.*

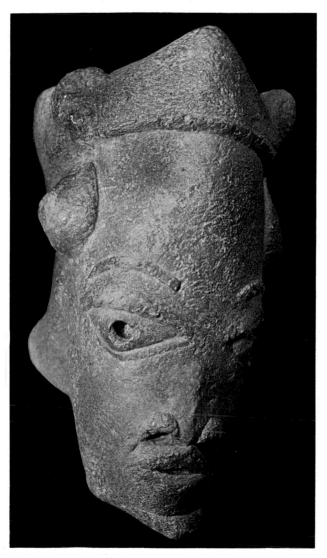

46 *Nok art : Head, in terracotta. London, British Museum.*

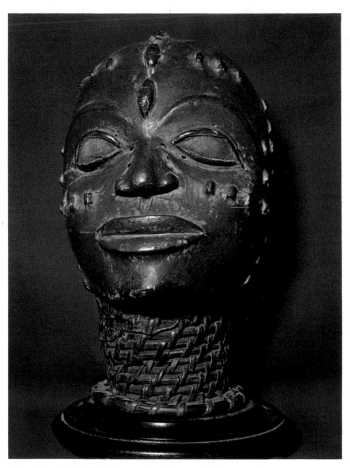

47 *Ekoi art : Head carved and covered in skin. Rome, Museo Pigorini.*

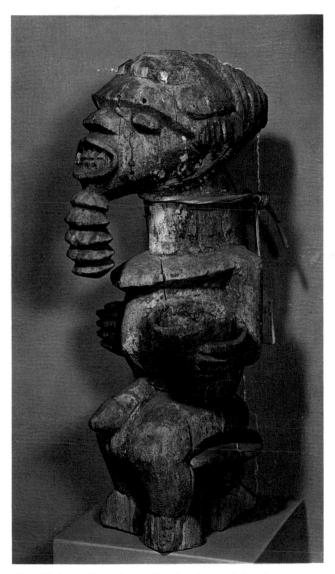

48 *Ekoi art : Seated man figurine, in wood. London,
British Museum.*

44 Ijo art: *Guardian spirit*, in painted wood. New York, Museum of Primitive Art.
This spiky creature has a face and body made up of a number of separate geometrical parts.

45 Ibibio art: *Mask*, in carved and painted wood. London, British Museum.
Ibibio masks and figures were to some extent mobile, for the jaw could be worked and there was some possibility of separate limb movement.

46 Nok art: *Head*, in terracotta. London, British Museum.
Part of a statue, this head is characterized by protruding lips and staring eyes with pupils clearly marked.

47–8 Ekoi art: *Head carved and covered in skin*. Rome, Museo Pigorini (on the left). *Seated man figurine*, in wood. London, British Museum (on the right).
Ekoi heads are among the most vigorous and impressive of African carvings. They fall into two categories, one group with a life-like appearance, the other displaying more expressive freedom.

49 Bamileke art: *Frame*, in wood. Paris, Musée de l'Homme.
From the wide field of African sculpture, this is a particularly rare specimen, intended to embellish a building.

50 Bamileke art: *Human mask*, in wood. Vienna, Museum für Völkerkunde.
There is no attempt here at the realistic: eyes, brows, ears and cheeks are treated with a roundness of form rather than the regularity of nature.

51 Bamum art: *Cremonial mask*, in wood. New York, Brooklyn Museum.
This Bamum mask, with its wide eyes, smiling mouth and unmistakable nose, is a fine example of realistic work.

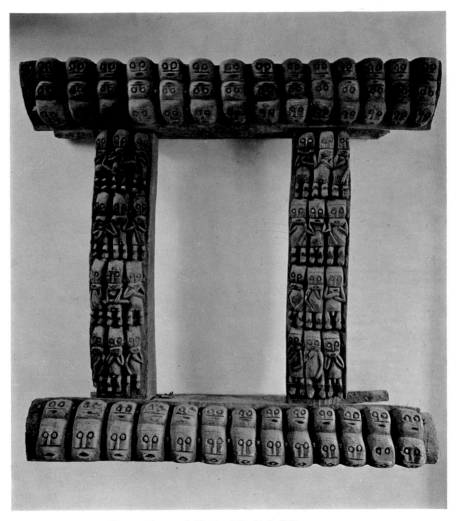

49 *Bamileke art : Frame, in wood. Paris, Musée de l'Homme.*

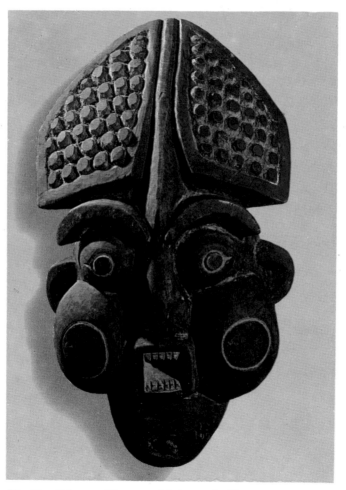

50 *Bamileke art : Human mask, in wood. Vienna, Museum
für Völkerkunde.*

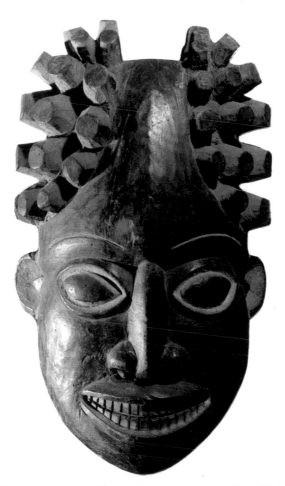

51 *Bamum art : Ceremonial mask, in wood. New York,
Brooklyn Museum.*

substitute for the dead person, and was nurtured by the family as if it were a living child. The mighty rams' heads are also most impressive, some with human lineaments. They were used in rites of the yam cult – the yam being the West African population's staple diet.

Ife heads

The town of Ife was a Yoruba religious centre. During the thirteenth century, it enjoyed a period of great splendour. It was here, in the year 1910, that a bronze head first came to light, followed by the discovery of eight more in terracotta, so admirably made as to bear comparison with Greek art of the sixth century BC. More have since been found and a number of fanciful explanations put forward as to their meaning and origin. The latest research considers them to belong within the compass of ancient Yoruba art. They may be commemorative of rulers or grandees, though not portraying actual individuals. The bronze heads were cast by the melted wax method; their dimensions are near life-size and on some the whole facial area is covered with close parallel lines which, it is thought, may represent body marks of a particular kind. Surrounding the mouth and along the lower jaw, and also on top of the head, there are irregularly-placed holes. It is assumed that these were for the purpose of adorning the head with some necklace-like ornament, marking the hair, beard and moustaches.

Benin culture
The town of Benin also produced sculpture, allied to the Ife style. It is nowadays believed that after the Ife influence had been assimilated, a more local style developed. Male and female heads, human and animal figures, masks of the cat tribe and most particularly high relief plaques are considered to be commemorative of ceremonial and sacrificial occasions. Cast in bronze, their detail and sheer skill establish them as outstandingly important. The earliest pieces go back to the fifteenth century at least. Like Ife work, they illustrate how highly developed was the standard of art in southern Nigeria in ancient times.

Ivories form another much sought-after group of art products. Arm-bands and masks, ornamentation and great elephant tusks were inlaid and worked in relief with traditional motifs. The elephant tusks, some of them enormous, served as records, either of historical occasions or the feats of war-leaders.

Minor art works
Along the lower reaches of the Niger and near the river mouth, art works so far located may be of minor importance but possess certain noteworthy features. Ijo water-spirit masks, for instance, are full of dramatic fire. The Ibibio produced two kinds of masks. One was a helmet, with a white strip over a natural-looking face, which served in ancestor worship. The other

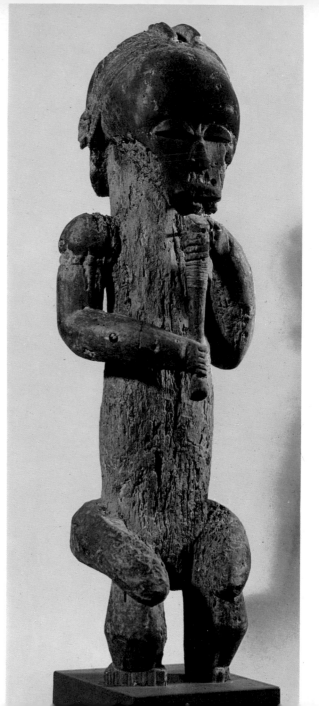

52 *Fang art :
Male figurine, in
wood, Paris,
Musée de l'Homme.*

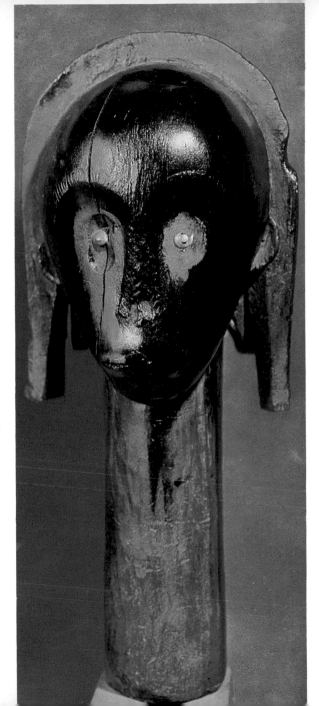

53 *Fang art :*
Head on long neck,
in wood. Paris,
Musée de l'Homme.

52 Fang art: *Male figurine*, in wood. Paris, Musée de l'Homme.
The Fang – also called the Pangwe – made masks of direct appeal and figures approaching the statuesque.

53 Fang art: *Head on long neck*, in wood. Paris, Musée de l'Homme.
Heads of this type on crane-like necks were set atop the baskets in which the Fang placed the bones of their dead. Among other functions, they were intended to keep evil spirits at bay.

54 Fang art: *Dance mask*, in wood. Milan, Priv. coll.
This is a representative Fang mask, although the heart shape is common to other African cultures.

55 Bakota art: *Anthropomorphic figure*, in wood with copper over-lay. Rome, Museo Pigorini.
Like the Fang heads, these wooden figures were meant to be on the receptacles that held the bones of the dead. Instead of a near-natural likeness, this particular one has a highly abstract effect.

56 Bakota art: *Reliquary figure*. Milan, Priv. coll.
The sole decoration on this piece consists of the thin copper strips which are overlaid on the face and highly symbolized body.

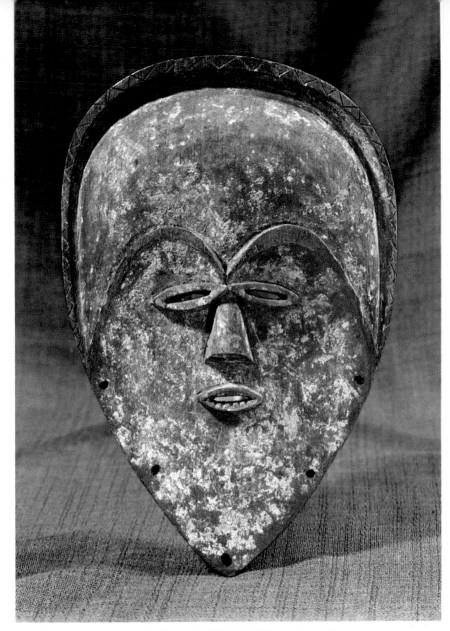

54 *Fang art : Dance mask, in wood (h **9** in). Milan, priv. coll.*

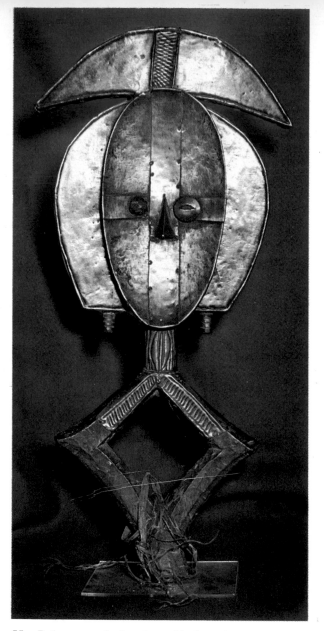

55 *Bakota art : Anthropomorphic figure in wood with copper over-lay. Rome, Museo Pigorini.*

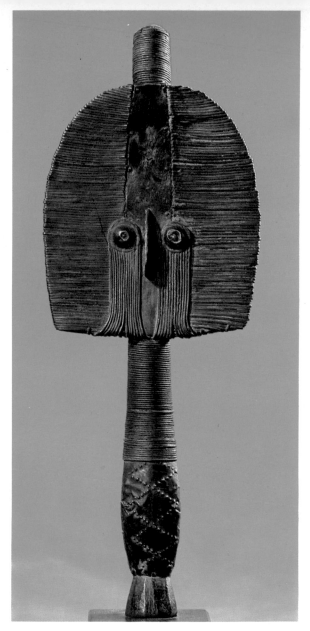

56 *Bakota art : Reliquary figure, Milan, priv. coll.*

was abstract and used in connection with the yam cult. The Ibibio also made figure-carvings, sometimes of the whole person and sometimes only the head, both of which types are powerfully expressive. Their grotesque masks have much in common with the art of the Ekoi, a people inhabiting the area between Nigeria and Cameroon. A leading chracteristic of the Ekoi was to cover their masks – often two-faced like a Janus – with animal skin, which made them that much more life-like and awe-inspiring. Some Ogoni masks demand attention for the stylized treatment of the face, often with animal features added – usually horns. They may be compared with Ibibio art. The Afo tribe, from the Niger-Benué confluence, specialized in ritual figure carving. They are noted for small wooden pieces, lively representations of personages. A little to the north in Jaba country, a culture has been discovered and called Nok after the village nearest the finds. This culture is dated to between the fifth and first centuries BC, on the basis of geological evidence from the site strata. Finds so far include heads and fragments of terracotta figures, as well as stone and iron artefacts. They show a successful blend of natural and abstract elements. But the very fact of such discoveries goes a long way to prove just how ancient are some of the current themes of Negro art, and how indigenous to Africa.

In Cameroon, the Bamum and Bamileke people have venerable artistic traditions. Masks, human

figures and receptacles, all carved, can be distinguished by a certain flatness and a natural treatment with occasional grotesque notes. Images of leaders were prized by the Bamileke, who placed a variety of carvings in their cult shrines and private homes.

The Fang of Gabon

Although the Congo area is vast, there is a good measure of agreement in terms of art. For example, the head of a figure is generally emphasized at the expense of the body's other organs. But there is no actual unity of style since each tribe, in art as in life, had its own particular language. In the forefront must be reckoned the Fang of Gabon, on the strength of their wood carvings. These represent the head or whole human figure and have considerable artistic merit. Intended for grave images, they were placed on top of a cylindrical receptacle which held the bones of the dead. Form is controlled and treated in the round, a gloss derived from coating with palm oil; the face is stern, as always in figures for ceremonial purposes. In the class of dance masks, those attributed to the Ngil society may be singled out for special mention. Here, form is very elongated and – unlike the figurines – they are coloured white.

The Bakwele and Bakota

Along the upper reaches of the Likwale river, the Bakwele produced art works in the Fang style. Some of their masks are very striking; solemn and heart-shaped, the oval face is circled in whole or in part by stylized horn motifs, with white colouring matter over part of the surface. More common, if less ancient, are the dance helmets, near-cylindriform and decorated with four concave faces in outline, and painted white. On the other hand, the Bakon of western Gabon and the middle Congo went in for a strictly two-dimensional effect: their reliquary figures, made to guard the bones of the dead, are abstract creations. These pieces comprise a large face, concave or convex, with a copper overlay and below it, a diamond-shaped body. Some have two faces, the one concave and the other convex. There is also a sub-style in this group, attributable to the Osyeba. Not unlike Bakota work in concept, the finish differs. It is, if anything, more abstract and the face area is covered with strips of copper and iron instead of the Bakota thin sheeting.

The Balumbo and Bateke

In the south-western quarter of Gabon, the Balumbo tribal group is noted for a special type of wooden dance mask. This was used by the Mukui secret society, and symbolized the spirit of the dead. A woman's face was represented, whitened, with high brows, almost closed eyes,

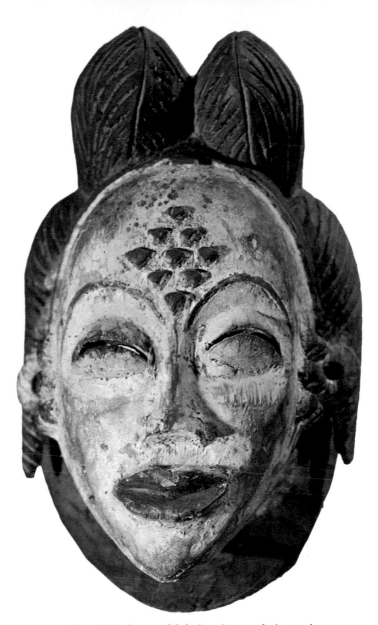

57 *Balumbo art : Mukui-society mask, in wood
(h 12 in). New York, Museum of Primitive Art.*

57 Balumbo art: *Mukui society mask*, in wood. New York, Museum of Primitive Art.
Balumbo masks featured an oval face and overall white colouring.

58 Bakongo art: *Figurine for a grave*, in wood. Tervuren, Musée de l'Afrique Centrale.
Prayerful is the descriptive term for these Bakongo figurines. The head is invariably held to the side or rests upon a knee.

59 Bakongo art: *Fetish*. Rome, Museo Pigorini.
The figure beneath the nails roughly resembles a person, with grass-skirt, feather and bits of leather in token of identity.

60 Bakongo art: *Motherhood fetish*, in wood.
A fetish can take many forms, either a human nude, with an ornament at the neck or on the head, an animal or some inanimate object such as a horn or vessel.

61 Bakongo art: *Gong stick with one human head on another*, in wood. Tervuren, Musée de l'Afrique Centrale.
This kind of stick would habitually be used by a shaman to summon devotees to purification rites.

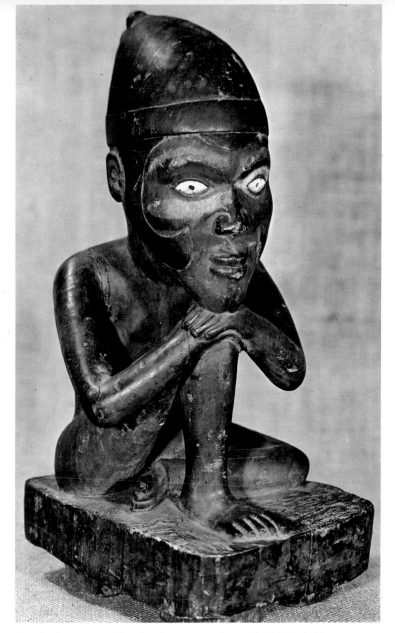

58 *Bakongo art : Figurine for a grave, in wood (h 16 in). Tervuren,
Musée de l'Afrique Centrale.*

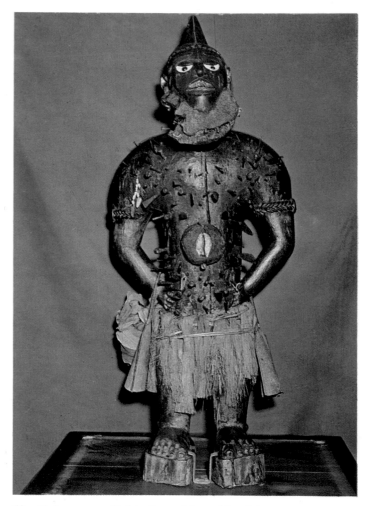

59 *Bakongo art : Fetish. Rome, Museo Pigorini.*

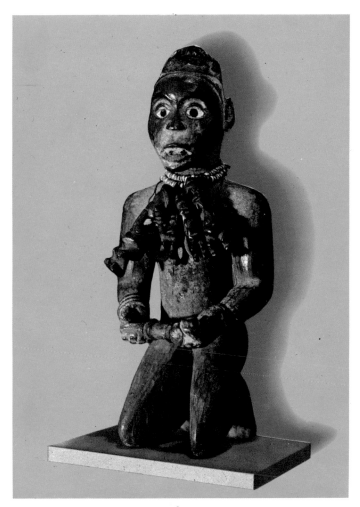

60 *Bakongo art : Motherhood fetish, in wood. New York,
Brooklyn Museum.*

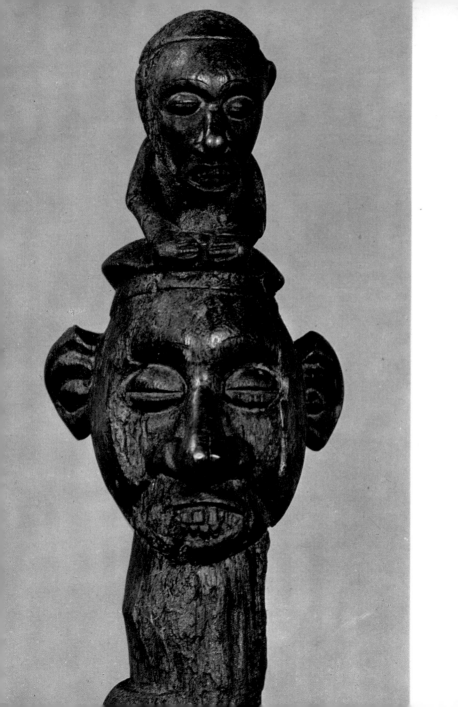

narrow nose and protruding mouth; the hair was brown. These masks are evocative, on several counts, of the Japanese theatre. In the region of the Congo river in its lower reaches, the Bateke have one of the most noteworthy styles of sculpture. Strange fetish figures, usually bearded, the body marked by longitudinal grooves and a small hollow in the abdomen where magic or protective substances could be placed.

Their abstract masks are also interesting. In disk form, they carry geometric patterns in various colours.

The Bakongo

In the region of the lower Congo river, on the borders with Angola, the Bakongo, people of Bantu stock, may be sub-divided into a number of tribes. Their art is of considerable importance. Ancestor worship has given rise to the making of figures, fashioned with some imagination and a wealth of realistic detail. Their gestures are dignified, their expressions solemn and pensive. Some of the best examples clearly commemorate dead notables. Superb female images are also found, sometimes sitting cross-legged, sometimes upright. Many of them hold or suckle babies and obviously they symbolize motherhood. On certain tombs in the Matadi region of Angola, soapstone figures have been found: the attitudes are unusual and they have a meditative, contemplative expression.

61 *Bakongo art : Gong stick with one human head on another, in wood (h 28 in). Tervuren, Musée de l'Afrique Centrale.*

Another interesting aspect of Bakongo art is the construction of fetish figures. These are made of wood, with animal or human features and roughly stylized. The body of each is coated in iron and nails have been stuck in, each marking an occasion when the fetish was demanded for a particular purpose. The mirror-fetish is another type, with a small mirror inset at the level of the abdomen; its purpose is to protect rather than to cause harm. A number show a raised arm, brandishing a javelin or knife.

The Bayaka and Bapende

In the region of the Kwango and Kwilu rivers live the Bayaka. Their art includes some very grotesque anthropomorphic figures, with huge ears, bulging eyes and enormous noses. The Bayaka dance masks have a huge fibre collar, and here again there is heavy emphasis on the nose, little more really than a protuberance. The face is rounded and painted white; not infrequently, an animal figure tops the mask.

A little to the south in the direction of the Angola border, the Bapende are noted for dance masks used in initiation rites. These represent a human face, characterized by a prominent forehead, arched brows, heavy-lidded eyes, stubby nose and mouth finished with pointed teeth. The face is painted tan, with details picked out in black and white. The hair is rendered by matted vegetable fibre.

In addition, the Bapende have been responsible

for the carving of small masks in ivory; these belong to initiates who have passed the tests for admission to the adult secret society. Carvings of personages are seldom found, but there is one outstanding example in the Musée de l'Afrique Centrale at Tervuren. This is a large figure of a woman with a child in one arm and an axe held upright in her right hand. This figure was originally intended to be placed on the roof of a chieftain's house.

The Bushongo

The Bushongo or Bakuba are neighbours of the Bapende. Their territory is delimited by the Kassai and Sankuru rivers, and they are thought to have arrived in the far north of the Congo about the first milennium of our era. Here they created an empire, which reached its peak in the early seventeenth century under king Shamba Bolongongo. It was a feudal-type administration with powerful nobles and officials attached to the royal court. As far as art was concerned, this led to a rather unusual situation, the emphasis being on works made for the court, and sculptures designed for ancestor worship having only subsidiary importance, in contrast with the art climate elsewhere.

Two Bushongo art styles may therefore be distinguished, the one connected with the court, the other with everyday life. In the first group come the famous statues of rulers, held to be one of the purest expressions of African art. They

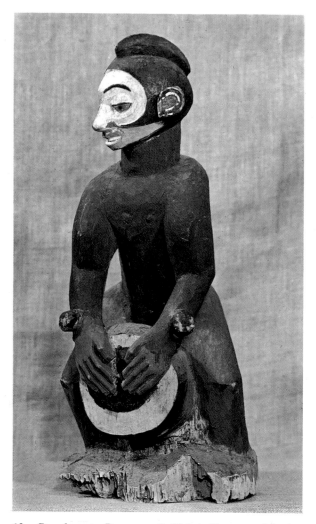

62 *Bayaka art : Drummer (h 28 in). Tervuren, Musée de l'Afrique Centrale.*

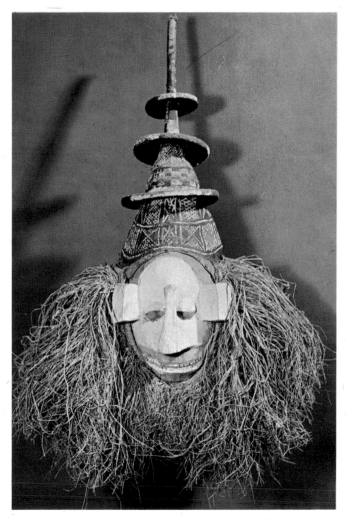

63　*Bayaka art : Mask, in wood (h 24 in). New York, Brooklyn Museum.*

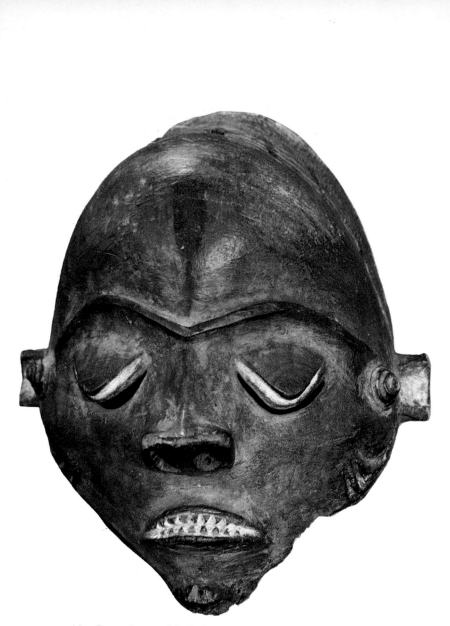

64 *Bapende art : Mask, in wood (h 11 in). Tervuren, Musée de l'Afrique Centrale.*

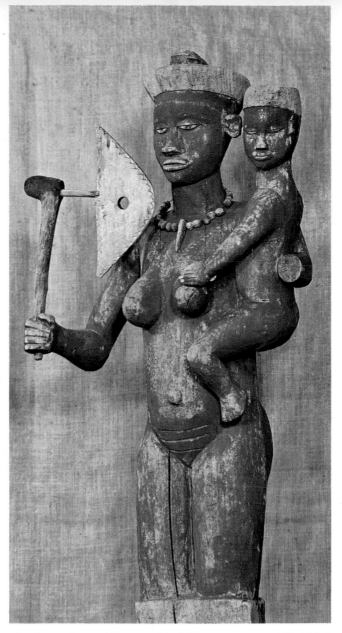

65 *Bapende art : Woman with child on arm, in wood (h 44 in).*
Tervuren, Musée de l'Afrique Centrale.

62 Bayaka art: *Drummer*. Tervuren, Musée de l'Afrique Centrale.
Bayaka work can be identified by the treatment given to the areas of the upper face. Hair encircles the face below the nose, and surrounds the eye sockets.

63 Bayaka art: *Mask*, in wood. New York, Brooklyn Museum.
A white facial area also dominates this Bayaka mask. The head-dress may culminate in an animal figure or, as here, in a pagoda-like structure.

64 Bapende art: *Mask*, in wood. Tervuren, Musée de l'Afrique Centrale.
Bapende masks are noted for their naturalistic appearance, though in most cases a dead man is portrayed rather than a living person.

65 Bapende art: *Woman with child on arm*, in wood. Tervuren, Musée de l'Afrique Centrale.
This figure was made for the roof of a headman's dwelling. Possibly it depicts the first of his wives.

66 Bushongo art: *Statue of a king*, in wood. Tervuren, Musée de l'Afrique Centrale.
Kata Mbuba, who is portrayed here, was the one hundred and ninth of his line and ruled in the early nineteenth century.

67 Bushongo art: *Dance mask*. Tervuren, Musée de l'Afrique Centrale.
Geometrical patterns cover by sections the whole mask area. The effect is most striking and highly decorative.

66 *Bushongo art : Statue of king, in wood. Tervuren, Musée de l'Afrique Centrale.*

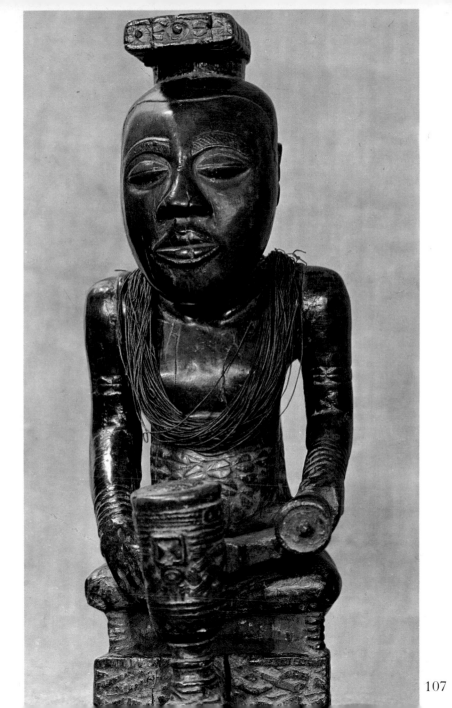

107

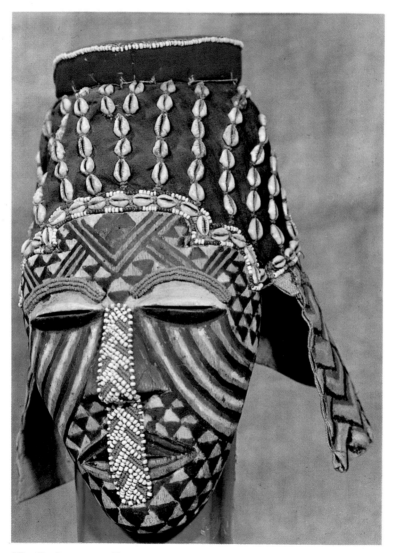

67 *Bushongo art : Dance mask (h 14 in). Tevuren, Musée de l'Afrique Centrale.*

represent a number of kings – history records there were more than a hundred of them – sitting cross-legged on a low throne. In front of this throne (a kind of cube) there is symbolized some outstanding event connected with the particular region. For example, the figure of a slave stands before the king who abolished some of the nobility's privileges vis-a-vis serfdom. The precise dating of these sculptures raises problems, though of course there is no doubt that some are old.

Bushongo popular art is a very different matter, compared with the masterly representation of the kings. The complete absence of ritual figures makes it hard to form a judgment. The human figure was seldom depicted and those of animals used for purposes of divination are very schematic.

The cups used for the rituals of various secret societies, which involved the drinking of palm wine, are of greater interest. They were made, for the most part, by tribes conquered by the Bushongo and represent either human heads – sometimes with animal features included – or upright human figures.

In the field of applied art, the Bushongo produced some finely-engraved boxes, and tam-tams. Six decorated examples of the latter group survive.

Masks call for separate consideration. Again, most were made by artists from tribes sub-jugated by the Bushongo. There is a distinctly

cubist air about them, enhanced by the poly-
chrome painting. Some are doubtless of com-
paratively recent date, since they are fashioned
out of woven material, animal skin and osier;
the decorative scheme includes cowrie-shells
and coloured-glass beads.

On the northern fringe of this area live the
Dengese. Their carvings are stylistically similar
to Bushongo popular art. There is intriguing
workmanship in the anthropomorphic figures,
created to mark the graves of dead leaders.

The Beni Lulua

In the south of the large Bushongo art region is
one tribal group which maintained individual
standards. The Beni Lulua parted from the
Baluba and settled the district in comparatively
recent times. Their sculpture includes anthro-
pomorphous figures and dance masks. There are
few specimens of the latter but they are of high
quality. Whatever the form or style, Beni Lulua
art is most distinctive. Thus in carved figures,
the articulation of the joints is always indicated,
in a manner somehow reminiscent of work by
the Fang of Gabon. The navel is emphasized,
sometimes protruding or even displacing the
belly. The figure always stands erect and is
covered by body-marks. The latest date for
Beni Lulua carving is thought to be about the
year 1880, when religious pressure was exerted
to forbid any further making of these figures.
Masks show some Bushongo influence but the

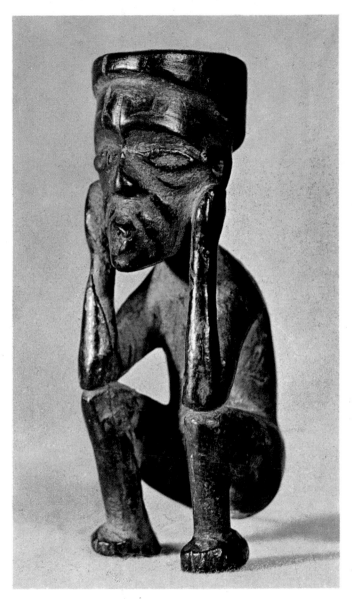

68 *Bena Lulua art : Fetish for hunting, in wood. Amsterdam, Tropenmuseum.*

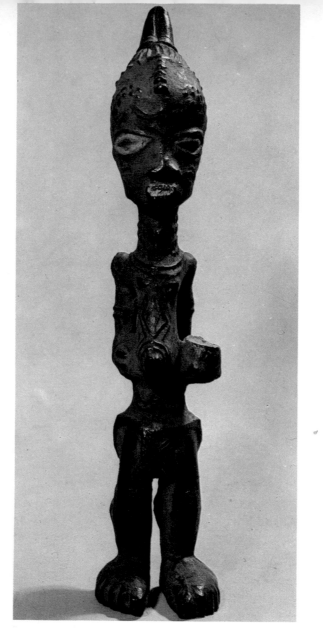

69 Bena Lulua art : Figure, in wood. Paris, Musée de l'Homme.

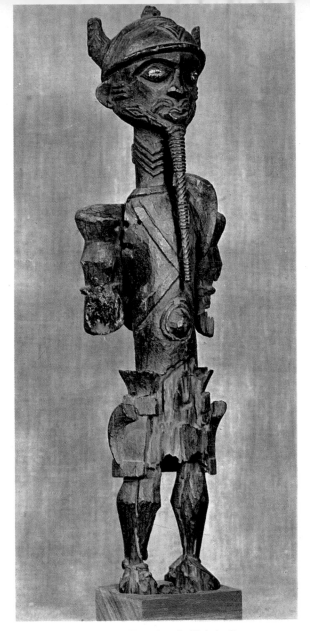

70 *Bena Lulua art : Warrior (h 32 in). Tervuren,
Musée de l'Afrique Centrale.*

68 Bena Lulua art: *Hunting fetish*, in wood. Amsterdam, Tropenmuseum.
One type of statue represents a standing figure, another (as here) a crouching figure. Elbows rest on the knee and the hands support the head.

69 Bena Lulua art: *Figure*, in wood. Paris, Musée de l'Homme.
Of value in the annals of African art, these figures are reckoned among the oldest to have survived. At all events, they stopped being made in the early nineteenth century.

70 Bena Lulua art: *Warrior*. Tervuren, Musée de l'Afrique Centrale.
Although Bena Lulua figures are seldom more than two feet high, they make a rather majestic impression. Here is a striking image of a soldier, ready for action.

71 Baluba art: *Cup*, in varnished soft wood. Tervuren, Musée de l'Afrique Centrale.
Cups served various purposes, some ritual and some obviously domestic. This particular piece has a kneeling female figure for the base and is accounted among the Buli master's finest creations.

72 Baluba art: *Bowl*, in wood. New York, Museum of Primitive Art.
Although a bowl may seem a common enough household object, the artist has found inspiration in it. The result is not only original but a technical feat.

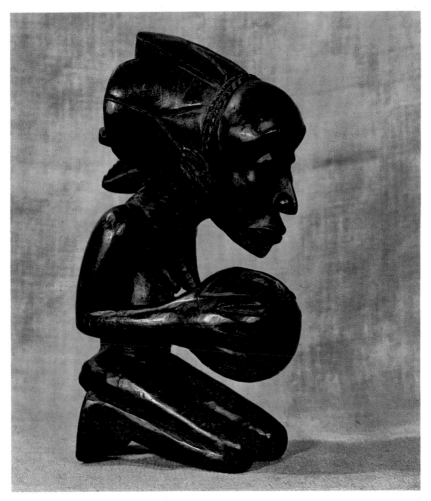

71 *Baluba art : Cup, in varnished soft wood (h 18 in). Tervuren, Musée de l'Afrique Centrale.*

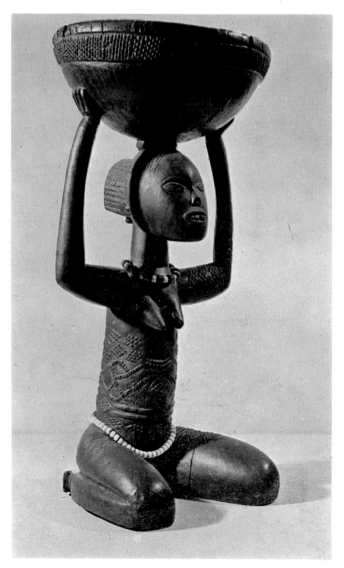

72 *Baluba art : Bowl, in wood (h 25 in). New York, Museum of Primitive Art.*

Beni Lulua individuality is still paramount. They are decorated in white, with some resemblance to the body-markings on the figurines.

The Baluba

In the southern Congo, the Baluba inhabit a huge area, with Lakes Mweru and Tanganyika on the eastern border. The Baluba people comprise a wide variety of tribal groups. Here, artistic development was strongly influenced by the court. But because of this multiplicity of strains Baluba art covers a maze of sub-styles. What most of them have in common is a certain roundness in the treatment of form, especially as related to the head, face, breasts and belly. The dressing of the hair is most carefully conveyed; so too is the modelling of the torso, while the hands and feet are sketchy by contrast. The female figure is the most popular theme, in many different poses, often serving as a stem or base for receptacles and other useful objects, such as drinking vessels, head-rests, pipes and drums. The artistic standard is excellent and may be distinguished by the gently rounded form and dark gloss. Their supremely natural quality contrasts with the view of proportion – distorted to a greater or lesser extent – illustrated among other Congo peoples.

In the mid-Baluba region, body-marks are specially accentuated, so too is the hair – in the shape of a cross. In the north, a more cubist outlook prevails. In the village of Buli, there is

exceptional merit in the Buli or long-face style. Usually on support-figures or those of kneeling women, they are deemed to be the work of one man on the ground of detail and of style. Baluba fetishes complete the range of carved figures; these have one or more heads and are of small dimensions. The making of masks does not seem quite on a par with Baluba work in other fields; but the most outstanding specimens bear comparison with the best that can be found elsewhere in the Congo.

The Basonghe

The Basonghe, of the Lualaba and Sankuru rivers region, belong to the Baluba complex, but show a stylistic difference. The human figure invariably receives cubist treatment. The face has a lozenge-shaped nose, the eyes often marked by inset cowrie shells and the mouth like a sideways-placed figure-of-eight. The whole head often carries copper and bronze pieces to highlight the features. The body as a whole is stiff, in contrast with the gently rounded forms of Baluba art. The effect here is more grotesque, indeed there is an aggressiveness in strong contradiction to the mild character inherent in the Baluba female figures. But the style is not lacking in impact and deserves consideration because of its singularity. The chosen theme is almost always the male figure. Fetishes commonly have the magic substance in a horn upon the head; less commonly, this may

73 *Basonghe art: Mask, in wood painted in red, black and white (h 41 in). Tervuren, Musée de l'Afrique Centrale.*

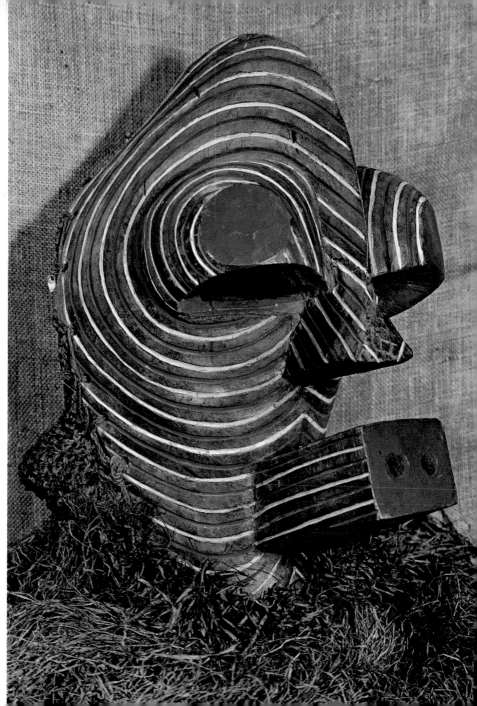

73 Bashonghe art: *Mask*, in wood painted red, black and white. Tervuren, Musée de l'Afrique Centrale. Masks such as this were worn by sick people, perhaps with the aim of embodying spiritual forces.

74 Bashonghe art: *Fetish*, in wood. Tervuren, Musée de l'Afrique Centrale.
This powerful, almost brutal statuette, with its sharp lines and corners and terrifying features, reflect the Bashonghe craftsman's direct, uncompromising style of expression.

75 Bajokwe art: *Seated man.* Lasne (Belgium), Priv. coll.
Bajokwe art falls within the Baluba cultural area. The purist treatment of form by the Baluba receives heavier emphasis here.

76 Warega art: *Anthropomorphic figure*, in ivory. Tervuren, Musée de l'Afrique Centrale.
Warega figures vary in size and structure but the treatment of the face is constant – a slightly bulbous forehead, marked brows, hollow cheeks and a small pointed chin, finished off with eyes in the shape of cowrie-shells.

77 Mangbetu art: *Jug*, in slate. Amsterdam, Tropenmuseum.
The neck of this jug represents a head, the high slanting coif being a distinctive touch. The body of the jug comprises a woman's breast with the motif of a suckling child.

74 *Basonghe art : Fetish, in wood (h 31 in). Tervuren, Musée de l'Afrique Centrale.*

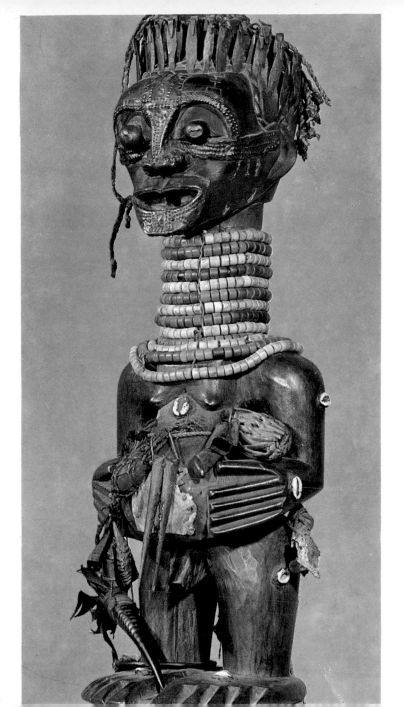

121

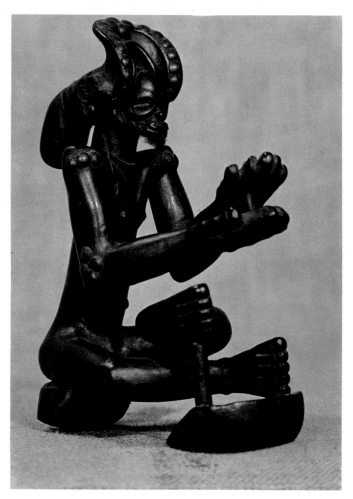

75 *Bajowke art : Seated man (h 10 in). Lasne (Belgium),
priv. coll.*

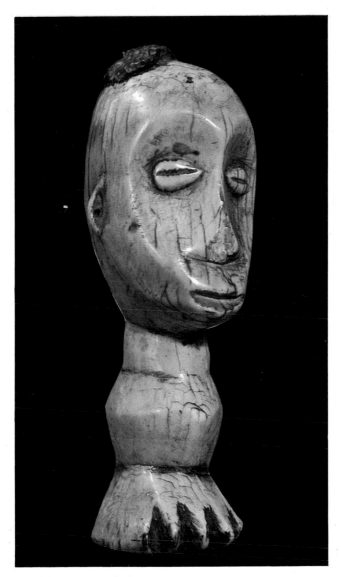

76 *Warega art : Anthropomorphic figure, in ivory (h 6 in).*
Tervuren, Musée de l' Afrique Centrale.

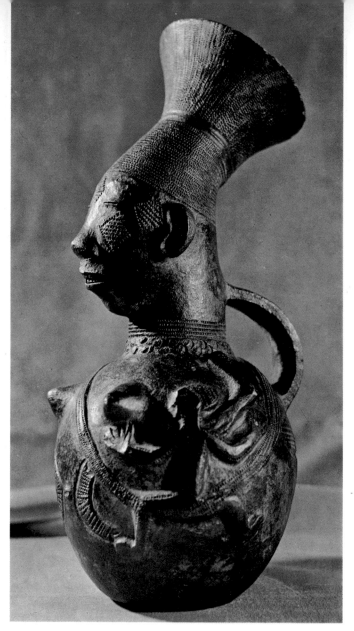

77 *Mangbetu art : Jug, in slate. Amsterdam, Tropenmuseum.*

be placed in a hollow specially made in the belly. The most famous examples of Basonghe art, however, are the dance masks of the *kifwebe* type. They are strongly abstract in presentation and cubist in the extreme. The human face is boldly stylized and cut by runnels which are often coloured in and contrast sharply with the mask's dark surface.

The Bajokwe

The Bajokwe belong in the southern Congo and part of north Angola. Their carved work is in many respects akin to the art of the Baluba. But what was full and rounded in a Baluba figure becomes altogether weightier and more massive in the hands of the Bajokwe. The head is larger, often masked and capped by a towering head-dress. The trunk is stout, the arms often meeting at chest-level. The legs are flexed and the feet large and flat. In common with the Basonghe and distinct from the Baluba, male figures abound. These are usually shown upright; the face is highly finished, and furrowed by the brows. The masked man as a theme is, incidentally, exceptional in the field of Congolese art. Many of the carved figures served as supporting pieces for useful objects. Great chairs are one example, their backs carved with motifs signifying deeds of war. The masks are also of interest, some being fairly stylized, other naturalistic.

The Warega

Warega sculpture is among the best of all the art of the Congo region. Its sources of inspiration are the rituals of the Bwame society whose initiations are social events among the different ethnic groups that go to make up the Warega people. Ivory is the medium used almost to the exclusion of all else. By its nature, it contributes sheen and some degree of stylization to the products which can be classified either as masks or persons, usually on the small side. On rare occasions, a mask will be made of wood but most are of ivory and are oval in shape, some more markedly so than others. The surface is convex with the face occupying a slightly concave position and having the features picked out in relief. The carvings of persons, busts or heads, have no eye to the natural proportions whatever; all the emphasis is on the head, sometimes on the hands as well. The eye-treatment is fairly general, consisting of a set-piece in the shape of a cowrie shell, sometimes with a real shell being applied.

The Mangbetu

By comparison with the great art styles of the west and east Congo regions, the north-east and Rhodesia have less to offer. In the north-east, interest focuses on the Mangbetu. Among their products are musical instruments, containers and handles for weapons. A recurrent motif, to which it is worth drawing attention, comprises

a human head, much elongated and with a high head-dress.

In ceramics, round-bodied vessels are much in vogue, their necks made like a female head which is carved in a manner resembling those made out of wood.

In northern Rhodesia, the Barotse have a distinct preference for grotesque surrealist masks, whereas the Mashona in the south are noted for head-rests having either a zoomorphic form or geometric design.

Traditional art in Africa is undoubtedly on the decline. Colonialism, imposing new conditions and life styles, religions such as Christianity and Islam, shattering the old beliefs in animals – these heralded the inevitable dissolution of tribal culture. For art was of the essence of society's spiritual life. From faith came inspiration and from the practices of that faith, the whole scope of artistic endeavour.

OCEANIC ART

Our discussion of Negro art has so far been confined to the African continent. We now switch our attention to the Pacific where primitive art of a similar kind flourishes among the peoples of Oceania. The main geographical areas here are Melanesia, Polynesia and Micronesia, each with their distinctive art styles but with enough similarities to suggest an underlying unity of culture and tradition. Although

this is a controversial subject, it is probable that their origin is in a long-lost civilization, whose life-style once influenced the whole Pacific. Everywhere, social life is subject to laws that must be obeyed and to sacred concepts. From them stem all artistic inspiration and the practice of ancestor worship with stress on the phallus and totem symbols.

The same kinds of artefact are found all over Oceania – statues and masks of ancestors, ornamental pieces, outrigger canoes, paddles, votive vessels and every kind of object for everyday use, many of which have hidden symbolical meaning. The sole exception is in Polynesia, where masks are never used.

Wood is a common material both for building and modelling. Sea-ivory, shells and clay are also used for sculpture. Stone is a rarity, though it may have been more often employed in the past. Unlike Africa, there is plenty of painting in Oceania not only to decorate sculpture but as an art in its own right. The painted bark 'leaves' are marvels of their kind, as are the *tapa* with their intricate designs. The *tapa* look and indeed feel like textiles but in fact come from tree-bark. A special procedure is needed, the bark being washed many times over and beaten with a special tool like a mallet. This softens the vegetable fibres and makes pieces of considerable breadth. Decoration is added by hand. In some instances, especially in Polynesia, wood stamps are engraved and steeped in the dye,

then pressed on the material. The habitual colours are brown, black and red.

New Guinea art

The richest art area in Oceania is undoubtedly that of New Guinea. For the diversity of its ways and styles, it occupies a special place within the Melanesian region. The central zone is inhabited chiefly by the Papuans, a black-skinned people. Their art centres are mainly in the Sepik river valley, along the shores of lake Sentani, the Purari delta and the Papua Gulf.

To the west, the Papuans are bordered by peoples of mixed culture, though Indonesian influence is strongly apparent. To the east live Melanesian peoples of purely local traditions. Papuan art, full of plastic vigour, is represented by a wide range of sculpture, from the monumental works of Lake Sentani to delicate touches on functional objects, such as *betel* spoons. Although there are certainly local differences of style as one moves from the Sepik to Lake Sentani and then on to the Gulf, the basic concepts are the same. All figures are composed on abstract principles, though there is also some attempt to present a subjective and arbitrary view of reality. As both these aspects are outside realist conventions, they can only be called surrealist. This trend is further emphasized both by the choice and application to face and body of colours. Among typical products are receptacles comprising an anthropomorphic

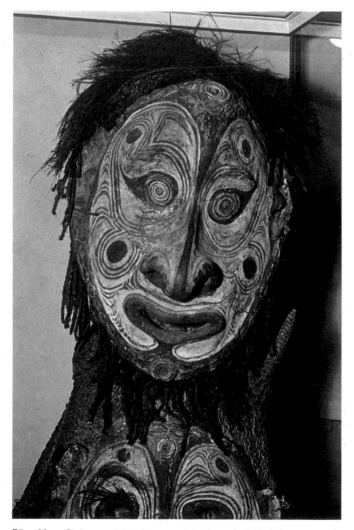

78 *New Guinea art (Sepik area) : Clan mask (h 72 in –
detail). Basle, Museum für Völkerkunde.*

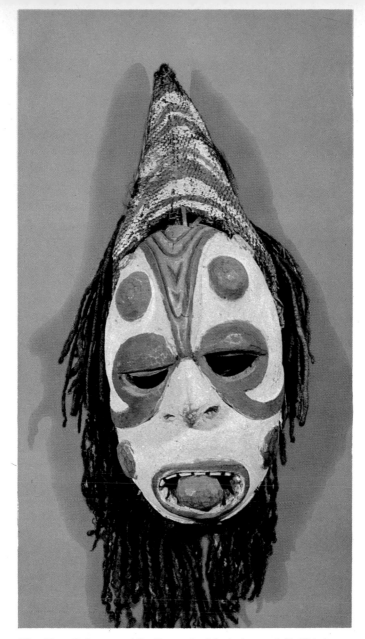

79 *New Guinea art (Sepik area) : Mask, in wood (h 18 in).*
Copenhagen, Nationalmuseet.

78 New Guinea art (Sepik area): *Clan mask* (detail). Basle, Museum für Völkerkunde. In the Sepik area, it was customary to hang gruesome figures such as this on the fronts of dwellings, to ward off evil spirits.

79 New Guinea art (Sepik area): *Mask*, in wood. Copenhagen, Nationalmuseet. This wooden mask has a clown-like aspect, due to the use of colour and the facial expression.

80 New Guinea art (Gulf of Papua): *Idol figure*, in wood. Basle, Museum für Völkerkunde. The human face is a recurrent feature of New Guinea art. Here, the features are picked out through a sequence of irregular curves with a vertical ridge for the nose.

81 New Guinea art (Lake Sentani area): *Motherhood*. Basle, Museum für Völkerkunde. In the Lake Sentani area, the human element in art is predominant. Sculptural form and decorative detail take precedence over painting.

82 New Guinea art (Fly area): *Stuffed human head*. Rome, Museo Pigorini. Ancestor worship led to the reworking of human heads. The intention was that such a head, restored, painted and embellished, would preserve the dead man's strength to the benefit of the living.

80 *New Guinea art (Gulf of Papua) : Idol figure, in wood. Basle, Museum für Völkerkunde.*

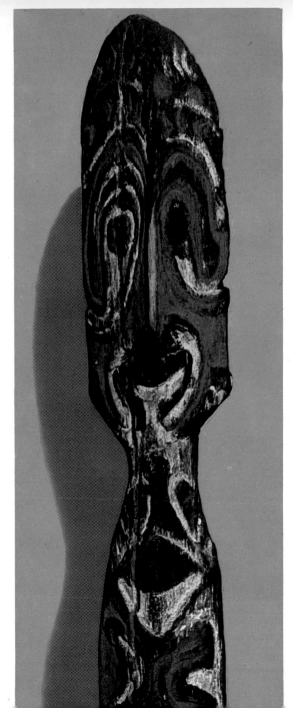

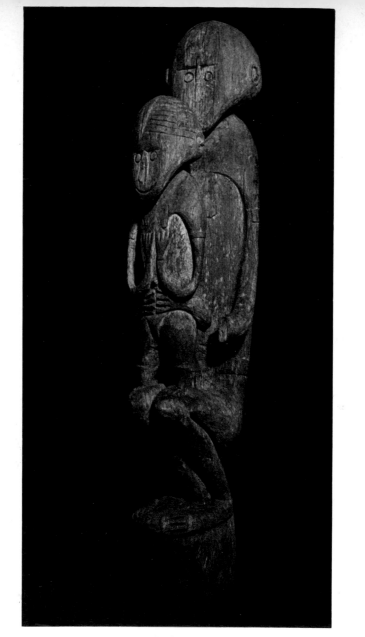

81 *New Guinea art (Lake Sentani area) : Motherhood
(h **37** in). Basle, Museum für Völkerkunde.*

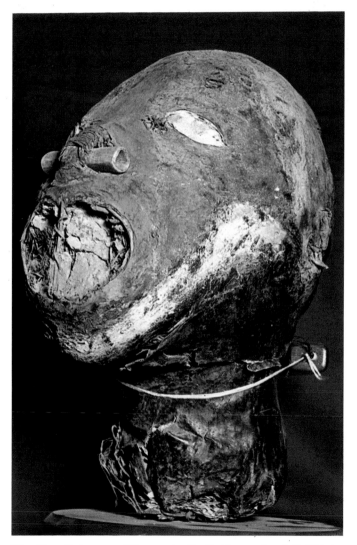

82 *New Guinea art (Fly area) : Stuffed human head (h 12 in).*
Rome, Museo Pigorini.

figure, and images that end in a double hook like an anchor on which weapons, clothes and victuals were hung.

The faces, especially in masks, have an extruded tongue and long narrow nose. The bird is a fairly common motif in Papuan work, envisaged on its own and in combination with a human figure in pieces of clearly anthropomorphic significance – where the bird may stand for the supreme deity. Another creature which often occurs is the crocodile, represented in conjunction with an ancestor figure. From the Lake Sentani region come some fine *tapas*, with religious themes, one being the tradition of the soul's journey by sacred canoe towards the countries of the sun. In western New Guinea, there is a special kind of ancestor statue called *korwar*, often capped by the dead man's own skull. In the east, there is a measure of identity with the distant Admiralty and Solomon Islands. In this zone great granite statues date back to antiquity, and illustrate the ritual use of stone.

In the Massim province, in the far eastern part of the island, masks are not found and statues of ancestors are uncommon. But spiral decorative elements abound and may perhaps derive from stylization of the frigate-bird. Exhibiting similar characteristics to those of Massim are the neighbouring D'Entrecasteaux and Trobriand archipelagos.

Other Melanesian centres

North of New Guinea lies the Bismarck Archipelago. Here, a Melanesian race inhabit the great islands of New Britain, New Ireland and the Admiralty Islands. The last-named are notable for wood receptacles, often of impressive proportions, shaped like a frigate-bird, or circular with animal totems or human figures as decorations. New Britain takes pride in its huge masks made of vegetable fibres and others, fantastically shaped, made of *tapa*. The surrealist flavour of Papuan art recurs in many impressive-scale works from New Ireland. Their masks are famous, as are the ancestor figures known as *uli* and the *malanggan* houses which were temples for the statues of that name.

East of New Guinea, the Solomon Islands group produced notable art works until two centuries ago; since then there has been a decline in art forms and a corresponding increase in mass-produced objects from craft studios. In northern islands of this group, stylized ancestor figures occur. One kind is known as 'hooded' from a particular head-gear. Masks are rare. The central islands have earned a reputation for making ornamental pieces for canoes, with realistic images dyed black and often inlaid with mother of pearl. The southern islands offer some fine bowls for ritual food purposes. Some take the form of a frigate-bird, others may be circular or elliptical. The handles are carved with totem or ancestor figures.

In the New Hebrides, one finds a characteristic style which is artistically as rich as anything in Papua. The range is very wide, both in form and decorative content. It includes great wooden drums in the open-space of villages, ritual posts on which the ancestor figure is carved, ornamental-pieces for canoes and great tree-bark masks with plant-fibre wigs. In addition, there are heads modelled in clay or other suitable material on coconut shells. Exclusive to the New Hebrides are large statues carved on tree-fern boles, which are among the finest art products of Oceania.

In New Caledonia, the lizard and bird symbols recur in token of the two sides of human life, material and spiritual. The ancestor figure, regarded as a source of protective power, appears everywhere. In representing human faces, stress is laid on the negroid character of the population, shown in the flaring nostrils and broad mouth. Stone is used for necklaces and ceremonial axes.

Polynesian art
To the east, Oceania stretches over a vast expanse of sea, studded with islands. It can be described as a triangle, stretching from New Zealand to Easter Island, and from there to Hawaii. Over the centuries, art forms have become largely ornamental. Polynesians no longer use masks or animal totems, and as a result, lizard or bird symbols are seldom encountered. A fish image is more frequent,

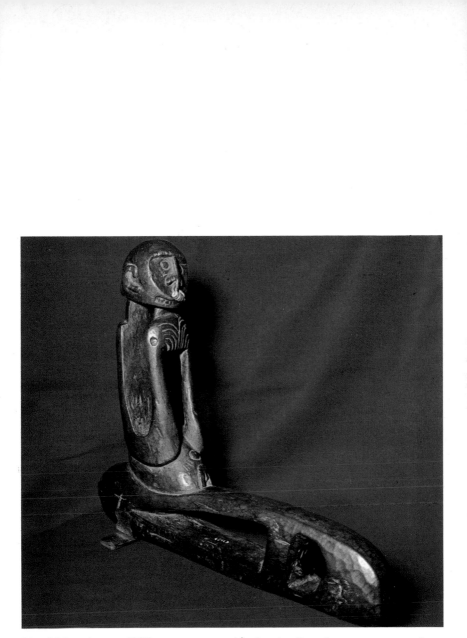

83 *Melanesian art (D'Entrecasteaux archipelago) : Seated woman ornament for a canoe, in wood. Rome, Museo Pigorini.*

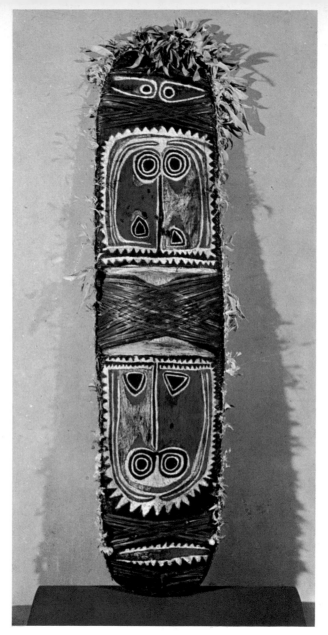

84 *Melanesian art (New Britain) : O'Mengen shield (h **60** in). Hamburg, Museum für Völkerkunde und Vorgeschichte.*

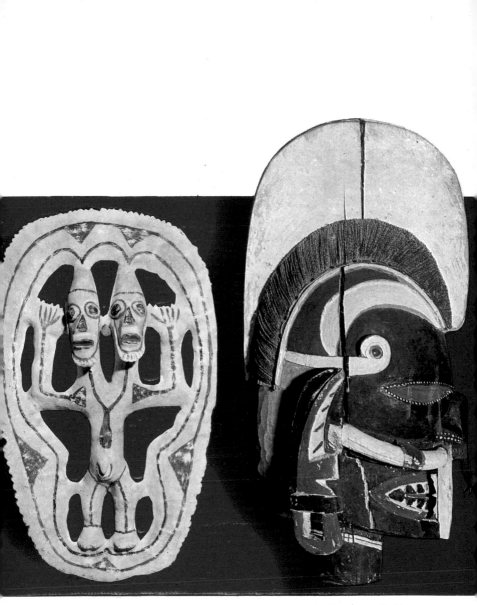

85 *Melanesian art (New Ireland) : Ancestor figure, in limestone (h 19 in).*
Hamburg, Museum für Völkerkunde und Vorgeschichte (on the left).
Malanggan head. Basle, Museum für Völkerkunde (on the right).

83 Melanesian art (D'Entrecasteaux archipelago): *Seated woman ornament for a canoe*, in wood. Rome, Museo Pigorini.
This piece has a primary appeal to the sense of touch and the work has similarities with that of the Massim district of New Guinea.

84 Melanesian art (New Britain): *O'Mengen shield*. Hamburg, Museum für Völkerkunde und Vorgeschichte. This shield carries decorative detail in white, red and pale blue, on a dark wood ground. Remnants of a woven-grass fringe may be seen at the edges.

85 Melanesian art (New Ireland): *Ancestor figure*, in limestone. Hamburg, Museum für Völkerkunde und Vorgeschichte (on the left). *Malanggan head*. Basle, Museum für Völkerkunde (on the right).
In these regions, the wood carvings and masks called *malanggan* play a leading part in religious ceremonies. They enshrine the personality of legendary heroes or ancestors.

86 Melanesian art (New Ireland): *Uli*, in wood. Basle, Museum für Völkerkunde.
Uli figures are made in the round and have a cylindriform body with separate patterned bands superimposed on it. Smaller figures often occur on the shoulders or belly.

87 Melanesian art (Solomon Islands): *Standing man*, in wood. New York, Museum of Primitive Art.
A rare piece. The modelling is straightforward, and there is no trace of colour. Body structure receives particularly sensitive treatment.

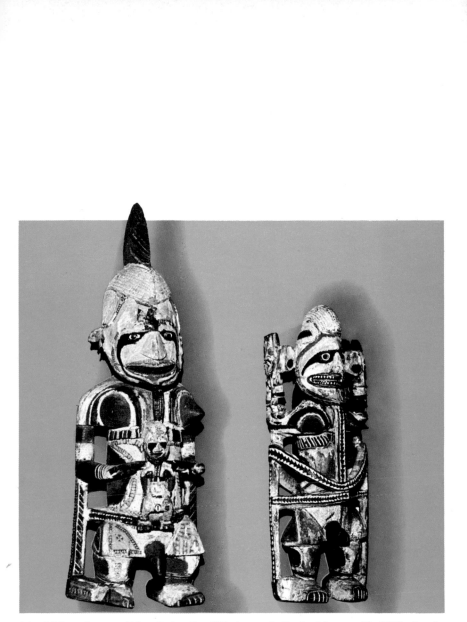

86 *Melanesian art (New Ireland) : Uli, in wood. Basle, Museum für Völkerkunde.*

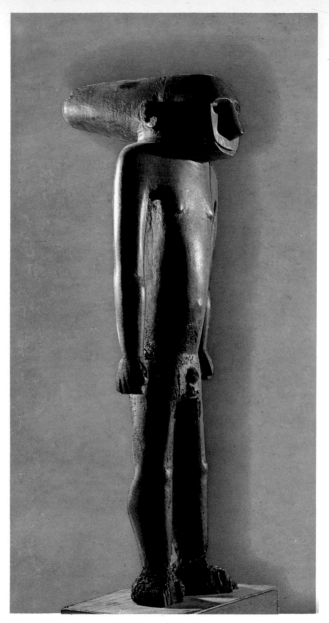

87 *Melanesian art (Solomon Islands) : Standing man, in
wood. New York, Museum of Primitive Art.*

derived from local fishing ritual. But one feature of interest is the motif of the *tiki* – a supernatural being of divine powers – interpreted in a geometrical patterning which sometimes recalls body-marks. Although the symbolical meaning is uncertain, these motifs perhaps echo some ancient system of notation which has passed from living memory. For in the *tapa* also, the geometrical style persistently occurs. Some attribute this lack of artistic wealth to the arrival on the scene of the Polynesians themselves, who drove out the original inhabitants. In western Polynesia – namely the island groups of Fiji, Tonga, Samoa and Wallis – some hint of such a tradition is perhaps discernible in the statues of ancestors. They are similar to New Guinea and New Caledonia work, though of course there are distinctive local touches. Taking the islands as a whole, the great painted *tapa* can be considered highly typical, together with engravings on wooden uprights, ritual vessels and paddles. In central Polynesia, a small number of carvings with anthropomorphic and zoomorphic features apart, items of artistic interest are few.

Main Polynesian centres

The outlook is far brighter in the eastern sector of Polynesia, which includes the Marquesas Islands and Easter Island. In the Marquesas, the *tiki* theme is seen everywhere, often characterized by a large stylized face. But the most

evocative images are the giants of Easter Island, many of them still in their original locations. There are two types. One group consists of anthropomorphous figures, roughly life-size or a little larger, cut from various types of stone and standing on the ground. The others are much bigger (some up to forty feet high), and are hewn from massive blocks of grey stone. These depict strange personalities with long heads and sketchy bodies. They have been placed on wide platforms comprising stones which have been smoothed and shaped, all, significantly, with their backs to the sea. There are also wooden figures of ancestors of some artistic merit, some life-like, others mingling the ancestor image with an animal totem.

In northern Polynesia, no single kind of carving can be taken as completely typical. In the islands of Hawaii, the *tiki* image occasionally shows some disproportion in the rendering of the head; anthropomorphic figures incline to be stiffly stylized. But here feathers come into their own, decorating masks which often verge on caricature.

New Zealand is the focus of artistic interest for southern Polynesia. The Maoris are expert wood-carvers, and once again the *tiki* theme occurs. This time there is a difference in that the tongue – sometimes a double-tongue – may be seen hanging from the mouth. The dominant motif is the spiral, skilfully executed whatever the context. Some of the finest *tiki* are made from jade.

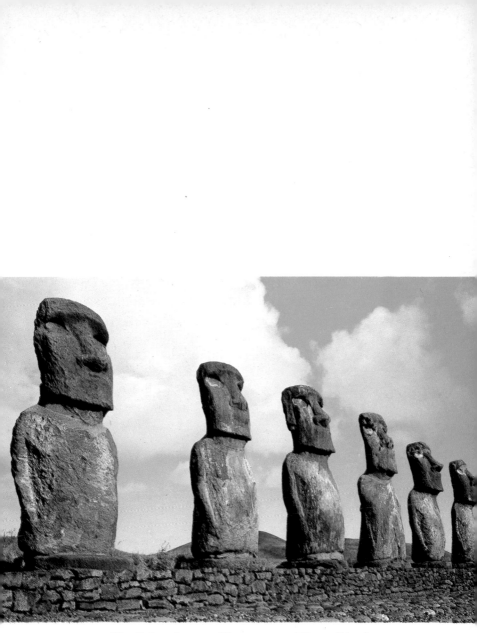

88 *Polynesian art : Giant statues of Easter Island.*

88 Polynesian art: *Easter Island statues.*
Also known as the seven Moai of Ahu-Akivi, these giant statues were erected in honour of the dead and have a ritual significance. They have occasioned much discussion and controversy.

89 Polynesian art: *God Tangaroa.* London, British Museum.
This wooden figure from Rututu in the Austral Islands has symbolical meaning; it represents the god Tangoroa, father of the other gods, giving birth to men and lesser deities who owe to him their origin and life. The interior is hollow and there is a wide aperture at the back.

90 Polynesian art (Hawaii Islands): *Head of the god Ku.* Honolulu, Bishop Museum.
Heads of Ku, god of war, were made of reeds woven together with long feathers knotted in. They were raised in battle as standards.

91 Polynesian art: *Fish hook* (on the left). *Tiki,* in wood (on the right). New York, Museum of Primitive Art.
The Maori people depicted their ancestors, even on everyday objects such as this fish-hook. The aim was to enhance the divine powers it contained.

92 Polynesian art (New Zealand): *Pendant of an ancestor,* in jadeite. Paris, Musée de l'Homme.
This pendant represents a *hei-tiki* – an ancestor who brings fertility. The figure is highly stylized.

89 *Polynesian art : God Tangaroa. London, British Museum.*

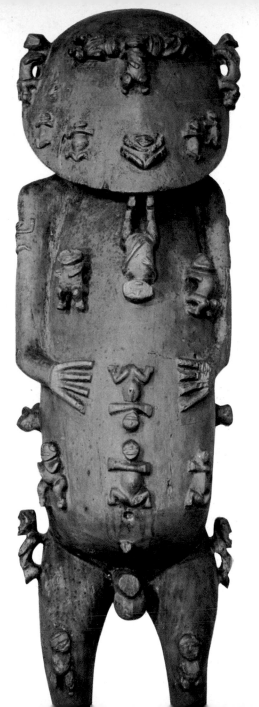

149

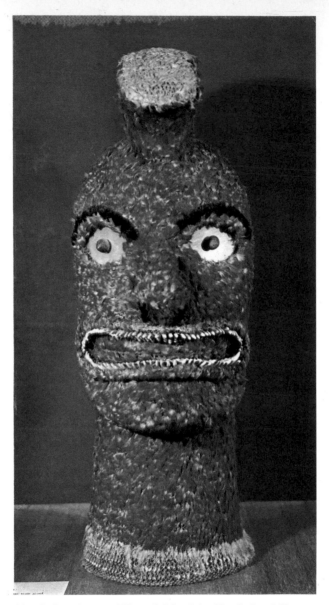

90 *Polynesian art (Hawaii Islands) : Head of god Ku.*
Honolulu, Bishop Museum.

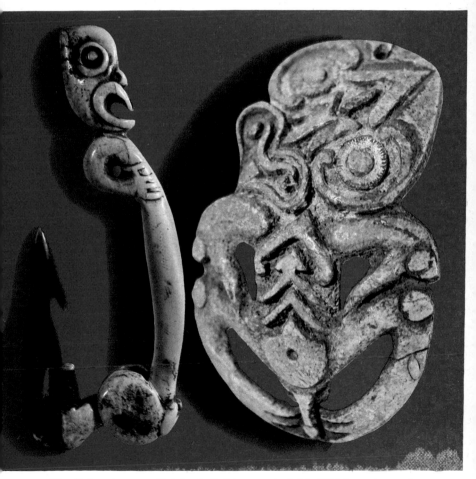

91 *Polynesian art : Fish hook (h **5** in – on the left). Tiki figure in wood
(4in – on the right). New York, Museum of Primitive Art.*

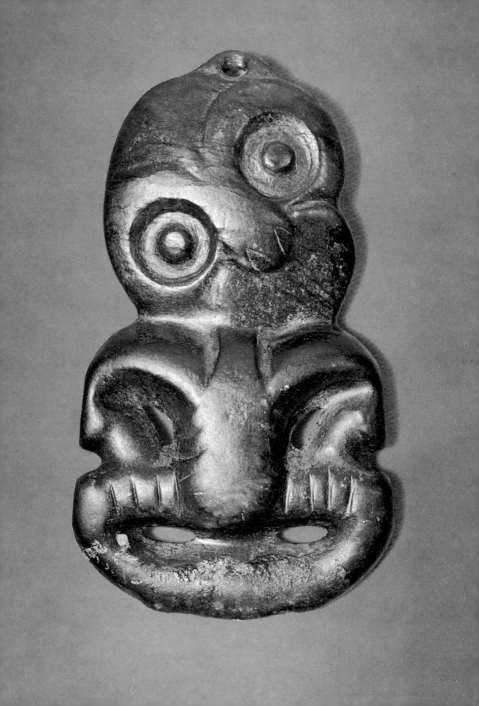

Micronesia

To the north of Melanesia, the area known as Micronesia covers a mixture of black, yellow and brown-skinned races. Artistic identities are correspondingly hard to distinguish. Native art has long been dead. There is a little sculpture, some of it of comparatively recent date, but the motivation is utilitarian rather than artistic. Elsewhere religious standards provided inspiration, but here they have vanished. The powers of the imagination seem equally untutored, the frame of reference going little beyond the demands of the everyday round. Art forms are so stylized and simplified as a result that their aesthetic merit cannot be rated especially high.

What has happened in Africa has been repeated in Oceania. The tides of history brought the white man and colonialism, and his attempts to superimpose foreign religions utterly destroyed the vigour and the art of native life.

92 *Polynesian art (New Zealand) : Pendant representing an ancestor, in jadeite. Paris, Musée de l'Homme.*

BIBLIOGRAPHY

R. B. DIXON, Oceanic Mythology, New York 1964

E. HEROLD, Tribal Masks: The Art of Africa, New York 1968

J. KERINA, African Crafts, New York 1970

F. MONTI, African Masks, London and New York 1969

W. M. ROBBINS, African Art in American Collections, New York 1966

C. A. SCHMITZ, Oceanic Art: Myth, Man & Image in the South Seas, New York 1970

C. A. SCHMITZ, Oceanic Sculpture, Sculpture of Melanesia, New York 1962

J. J. SWEENEY, African Negro Art, New York

J. J. SWEENEY, African Sculpture, Princeton 1970

M. TROWELL, African Design, New York 1965

R. S. WASSING, African Art: Its Backgrounds & Traditions, New York 1968

INDEX OF ILLUSTRATIONS

155